W9-BSL-817

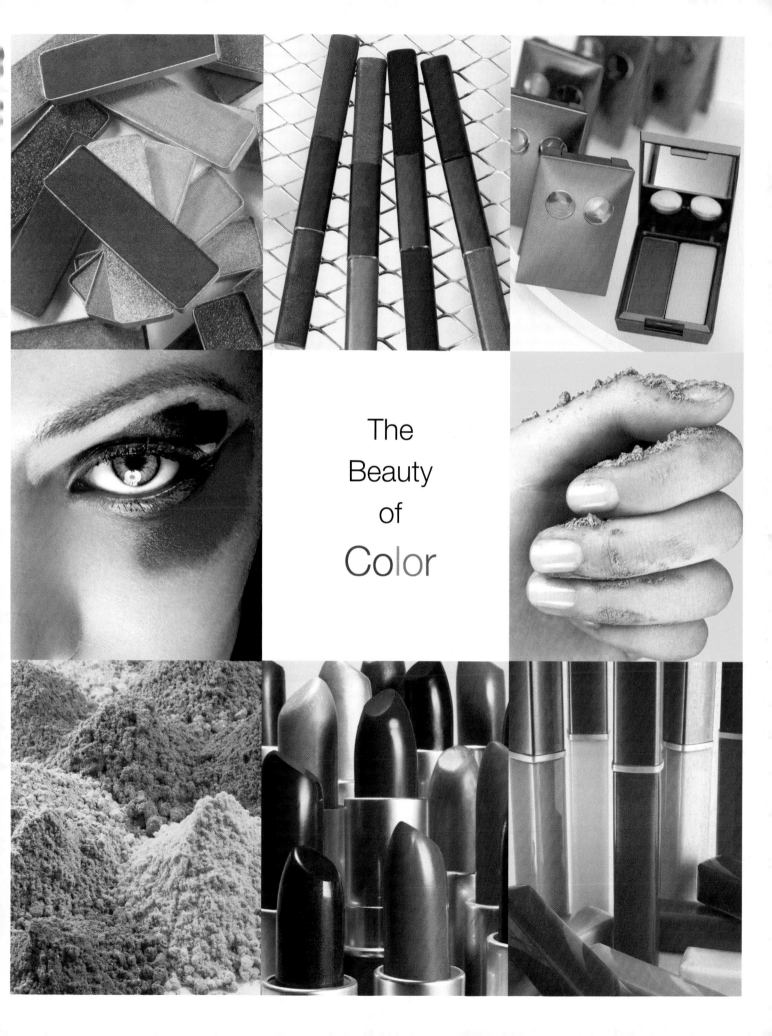

The
Beauty
of
Color

NEW YORK WOMAN

Bewitched,
Bothered and
Bewildered

**David Mamet
on Women**

The Younger Man

Blair Brown

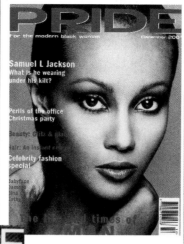

ESSENCE
VISIONS

STEVIE WONDER: WHAT HE SEES

HOW TO KEEP YOUR LOVE ALIVE

RED-HOT HOLIDAY FASHIONS!

'COTTON CLUB': THE MOVIE, THE REALITY

JAMES BALDWIN AND ADEIE LOOSE: A FRANK TALK ON RACE AND SEX

THE MAGAZINE FOR TODAY'S BLACK

PRIDE
for the modern black woman
December 200

Samuel L Jackson
What is he wearing under his kilt?

Perils of the office
Christmas party

Beauty: Glitz & gla...

Celebrity fashion
special

Babyface
...hanage
Ntia...
Birthd...

the ... times of

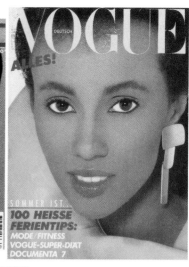

VOGUE
DEUTSCH

ALLES!

SOMMER IST...

**100 HEISSE
FERIENTIPS:**
MODE / FITNESS
VOGUE-SUPER-DIÄT
DOCUMENTA 7

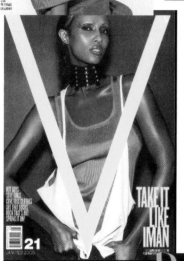

V

HOT BUYS
SEXY GIRLS
CUTE THIS CLOTHES
GET THIS LOOK
ROCK THIS ART
SPRING IS ON!

**TAKE IT
LIKE IMAN**

21

JAN / FEB 2003

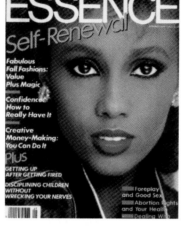

ESSENCE
Self-Renewal

**Fabulous
Fall Fashions:**
Value
Plus Magic

**Confidence:
How to
Really Have It**

**Creative
Money-Making:
You Can Do It**

PLUS

GETTING UP
AFTER GETTING FIRED

DISCIPLINING CHILDREN
WITHOUT
WRECKING YOUR NERVES

Foreplay
and Good Sex

Abortion Rights
and Your Health

Dealing Wi...

more

WOMEN WHO FOLLOWED
THEIR PASSION AND
CHANGED THEIR LIVES

**SEX CAMP
FOR BOOMERS**

IN BODY'S CHANGING
OR CHECKUP SHOULD DO
MUST-DO'S NEXT TIME

**SELF-DESTRUCT
SYNDROME**
WHEN THE BEST
AND BRIGHTEST GO
OFF THE DEEP END

**BRIGHT &
BREEZY**
EASYGOING SPRING CLOTHES, HEY-LOOK-AT-ME WATCHES
HOT COLORS FOR LIPS AND NAILS

IMAN
STRIKES
GO

FROM
SUPERMODEL
TO CEO
AND SHE'S GOT
A GREAT GUY
(DAVID BOWIE)

BIGGEST
April Ever!

ENTER
OUR 'SO...
SEARCH
...

TRACE

IMAN
beyond glamour

Pride
May 1998 · £2.20
for the woman of colour

BRINGING UP BABY
A man's story

WORKING GIRLS
When prostitution is
more than a game

J-LIFE
Urban jazz warriors
shake it loose

**EAT YOUR WAY
TO BETTER SEX**

**FASHION:
SHARP CUTS**
Suits with
an edge

Iman
Life After Tia Maria

FREE: IMAN VOUCHERS WORTH £30

BAZAAR
ITALIA

AUTUNNO INIZIA IL GRANDE FREDDO
LE PELLICCE, I CAPPOTTI
LE MANTELLE

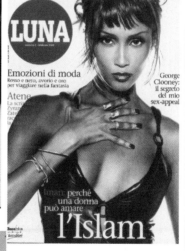

LUNA
versione C - Arsizione 2003

Emozioni di moda
Rosso e nero, avorio e oro
per viaggiare nella fantasia

Atene
La scri...
Zyran...
Zate...
rac...
la...

George
Clooney:
il segreto
del mio
sex-appeal

iman: perché
una donna
può amare
l'Islam

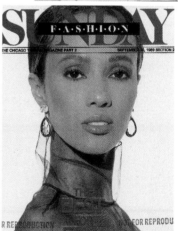

SUNDAY
F·A·S·H·I·O·N
THE CHICAGO T... MAGAZINE PART 3 SEPTEMBER 10, 1989 SECTION 2

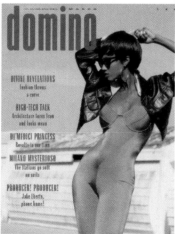

VOGUE
ITALIA

ROMA ALTA MODA

Horst fotografia
il Valentino
a ...

domino
MARCH

DIVINE REVELATIONS
Fashion throws
a curve

HIGH-TECH TALK
Architecture turns icon
and looks anew

DE'MEDICI PRINCESS
Royalty in our time

MILANO MYSTERIOSO
The Italians go soft
on suits

PRODUCER! PRODUCER!
Jake Eberts,
phone home!

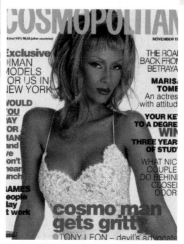

COSMOPOLITAN
NOVEMBER 1...

Exclusive
IMAN
MODELS
FOR US IN
NEW YORK

WOULD
YOU
PAY
FOR
A
IAN
and
...ve
...on't
...ean
...nch

THE ROAD
BACK FROM
BETRAYA...

MARISA
TOME...
An actress
with attitud...

YOUR KEY
TO A DEGRE...
WIN!
THREE YEARS
OF STUDY

WHAT NIC...
COUPLE...
DO BEHIN...
CLOSE...
DOOR...

GAMES
People
Play
at work

**cosmo man
gets gritty**
TONY LEON - devil's advocate

VOGUE
DEUTSCH

Wenn Sie
an das Leben
hohe Ansprüche
stellen, haben
Sie auch Anspruch
auf die VOGUE!
Auf jede VOGUE!

BESTELLSCHEIN

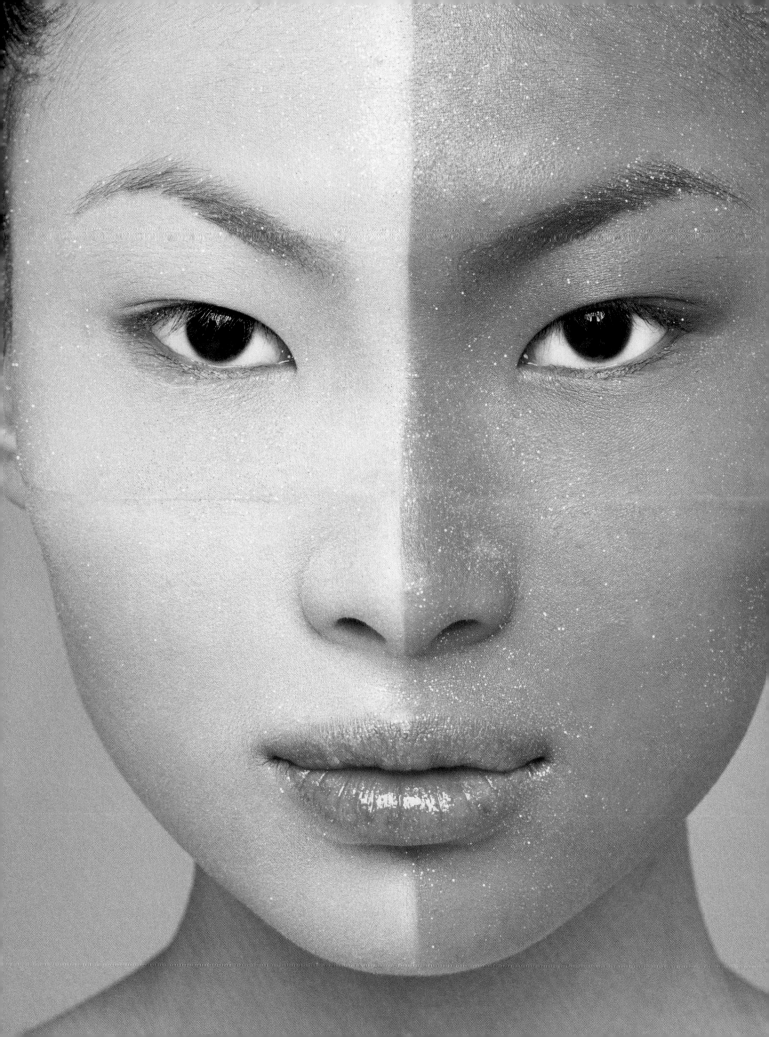

The Beauty of Color

The Ultimate Beauty Guide for Skin of Color

Iman

with Tia Williams

G. P. Putnam's Sons
New York

G. P. PUTNAM'S SONS
Publishers Since 1838
Published by the Penguin Group
Penguin Group (USA) Inc., 375 Hudson Street,
New York, New York 10014, USA • Penguin Group
(Canada), 90 Eglinton Avenue East, Suite 700,
Toronto, Ontario M4P 2Y3, Canada (a division of
Pearson Penguin Canada Inc.) • Penguin Books
Ltd, 80 Strand, London WC2R 0RL, England •
Penguin Ireland, 25 St Stephen's Green, Dublin
2, Ireland (a division of Penguin Books Ltd) •
Penguin Group (Australia), 250 Camberwell
Road, Camberwell, Victoria 3124, Australia (a
division of Pearson Australia Group Pty Ltd) •
Penguin Books India Pvt Ltd, 11 Community
Centre, Panchsheel Park, New Delhi–110 017,
India • Penguin Group (NZ), Cnr Airborne and
Rosedale Roads, Albany, Auckland 1310, New
Zealand (a division of Pearson New Zealand Ltd) •
Penguin Books (South Africa) (Pty) Ltd, 24
Sturdee Avenue, Rosebank, Johannesburg 2196,
South Africa

Penguin Books Ltd, Registered Offices:
80 Strand, London WC2R 0RL, England

Library of Congress Cataloging-in-Publication Data

Iman, date.
 The beauty of color : the ultimate beauty guide
for skin of color / Iman.
 p. cm.
 ISBN 0-399-15318-7
 1. Beauty, Personal. 2. Cosmetics.
3. Women, Black—Health and hygiene.
4. Minority women—Health and hygiene.
5. Models (Persons). I. Title.
 RA778.I455 2005 2005046575
 646.7'2'08996073—dc22

Printed in the United States of America
10 9 8 7 6 5 4 3 2

This book is printed on acid-free paper. ∞

Book design by Vincent Nigro

While the authors have made every effort to provide
accurate telephone numbers and Internet addresses
at the time of publication, neither the publisher nor
the authors assume any responsibility for errors,
or for changes that occur after publication. Further,
the publisher does not have any control over and
does not assume any responsibility for author or
third-party websites or their content.

Neither the publisher nor the authors are engaged in
rendering professional advice or services to the
individual reader. The ideas, procedures, and
suggestions contained in this book are not intended
as a substitute for consulting with your physician.
All matters regarding your health require medical
supervision. Neither the authors nor the publisher
shall be liable or responsible for any loss or damage
allegedly arising from any information or suggestion
in this book.

I dedicate this book to my daughters, Zulekha and Alexandria, and to all the beautiful girls around the world who march to the new world beauty beat.

Contents

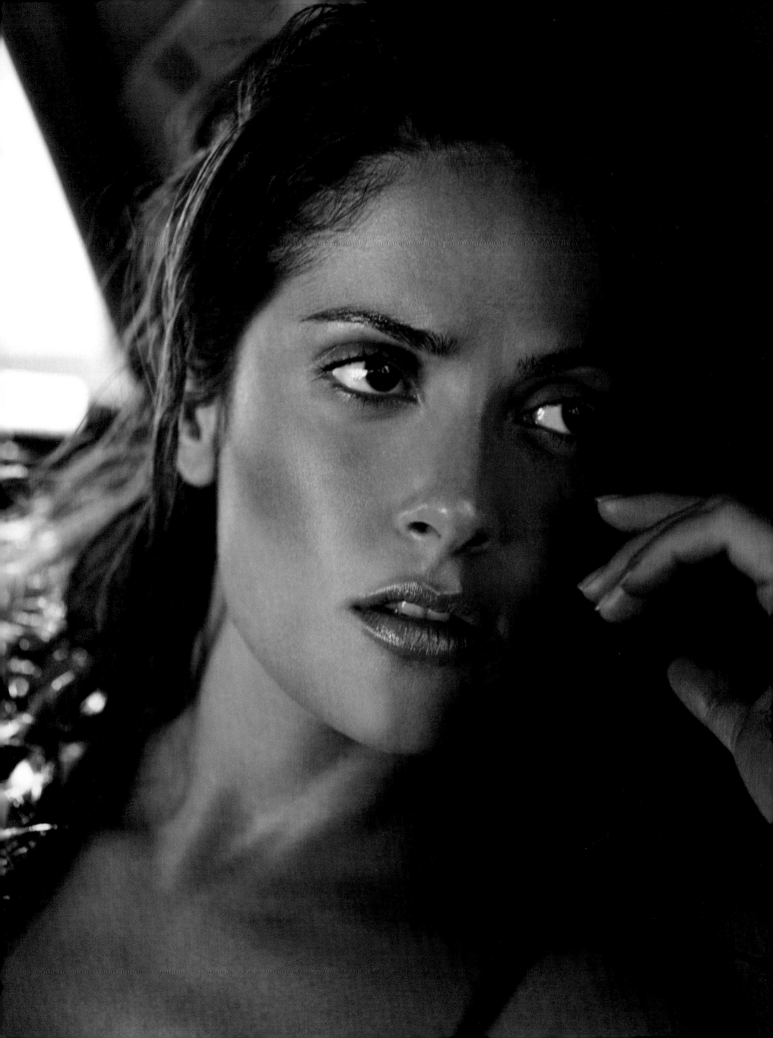

Foreword

The world's most unforgettable beauties are often women who fall outside of the narrow definition of trying to conform to a "type." These women make a journey into discovering who they are and embrace the very traits that set them apart. Their beauty is a glorious reflection of being comfortable in their own skin.

Unfortunately, we are a society that follows trends and allows others to define beauty for us.

Women have been expected to imitate the trends of "beauty" throughout history. Ironically, a body shape that could be perceived as big today would have been perfect in a different time or culture, and lips that have gone through so much pain to be artificially inflated—because today big lips are considered sexy—in the past would have been looked on as a deformity, even though in Africa, elongating lips has been around forever.

If you think about it, no matter what you look like you were, for sure, perceived as beautiful in some time or place. But do *you* feel beautiful?

People often say that "beauty is in the eye of the beholder," and I say that the most liberating thing about beauty is realizing that *you* are the beholder. This empowers us to find beauty in places where others have not dared to look, including inside ourselves. Behold yourself as beautiful. Have the courage to celebrate the things about you that are unique. Find beauty in everything you are, even your weaknesses; let the beauty of your spirit shine through imperfections.

If you are the eye of the beholder, is this eye looking at life through your own fears and insecurities? Or through your own beauty? It is up to you to make that decision.

If we see ourselves as beautiful, then we can see the beauty in others and others can see the beauty in us.

If beauty is in the eye of the beholder, then what we find beautiful says a lot about who we are and our limitations.

I think that happiness relies a lot upon our ability to find beauty in everything in life; therefore, I am mostly a very happy person, because I can find beauty in just about everything, from planets to bugs, from flowers to rocks, in people of all colors, sizes and ages. I find it in smiles with broken teeth and crooked mouths, in sunsets and rainy days, but most of all I find it in the courage to be unique and the passion to discover and celebrate who we are as individuals.

Iman is one of the most beautiful women in the world. She walks through life with the grace and elegance that comes from being proud of who she is.

Iman means "magnet" in Spanish, and what an appropriate name for a woman with eyes that capture and almost hypnotize you. In them, you sense a woman who has seen and loved the world for its diversity and its endless potential for beauty.

In *The Beauty of Color*, Iman pays tribute to women in all their delicious natural hues—from caramel, toffee, and buttermilk to cinnamon, chocolate, and nutmeg.

This book will take you far beyond makeup techniques and beauty tips to help you rediscover the power that comes from embracing every quality that makes you an unforgettable, unique beauty.

Enjoy!

—Salma Hayek

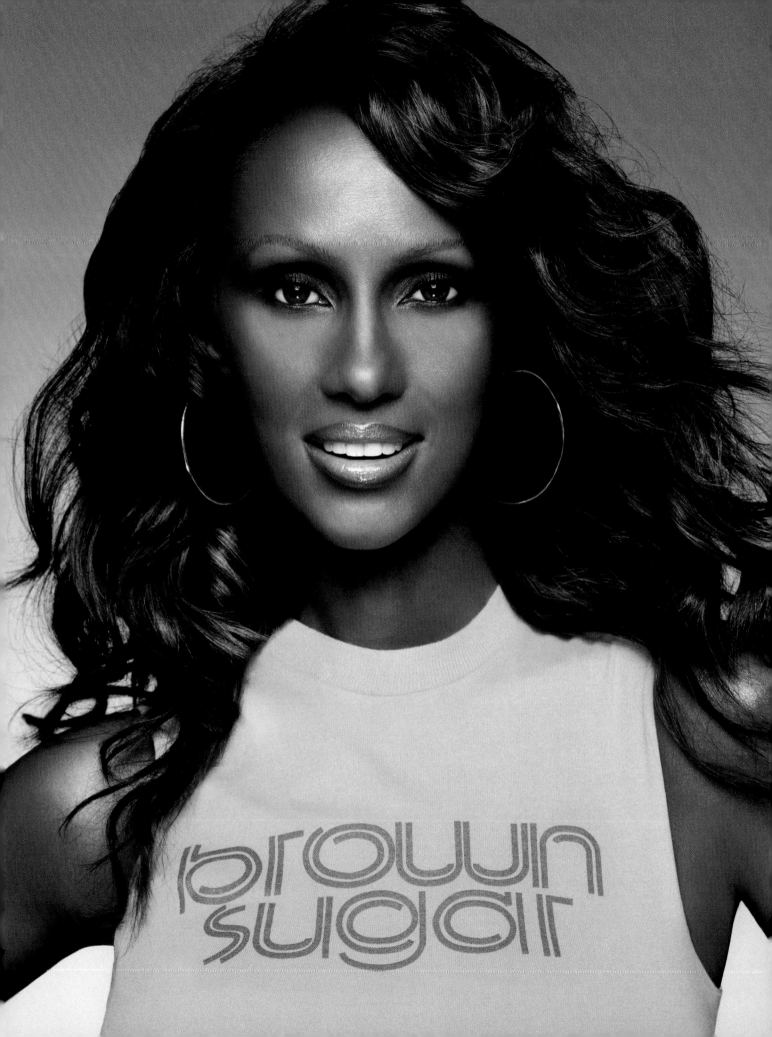

Introduction: CounterCulture

I arrived in America from Africa in 1975 to model.

At the time, I had been a student at Nairobi University, majoring in political science, and I'd never worn makeup before—nor heels, for that matter. My first photo shoot, two days after I arrived in Manhattan, was with one of the first celebrity makeup artists, Way Bandy, and legendary fashion photographer Francesco Scavullo. Bandy had the smallest makeup kit—a brown pencil, a black pencil, black mascara, an eyelash curler, baby powder, and an orangey blush. He said he would create the right "base" for me—in 1975 it was called "base," not "foundation"—and for the next half-hour, he mixed together a bunch of foundation colors—brown, yellow, red, and tawny. Imagine, thirty minutes to create the right shade. But this experience would prove to be the exception in the modeling industry.

As I started working professionally for high-end magazines, I was subjected time and time again to this perplexing question from makeup artists: "Did you bring your foundation?" It was a question never asked of my Caucasian counterparts. Photo after photo of me with disastrous skin tone made me realize that I had to learn the art of base for myself.

I started mixing and matching foundations. I'd play chemist, mixing up to three different colors to achieve the perfect combination to match my skin (more on this in the foundation section).

Even though I was one of the top models in my day, I never had an artist do my makeup at fashion shows—I always did my own. In fact, the celebrated models of my generation were a diverse group of global beauties—Pat Cleveland from New York City, Dalma from Brazil, Marie Helvin from Hawaii, Mounia from Martinique, Kirat from India, and Sayoko from Japan—and I assure you, makeup artists almost never had the right makeup for any of us. I needed to do something, as much for myself as for all the global girls I knew, so I decided to launch IMAN Cosmetics, a skincare and cosmetics line for skin of color.

Before I began creating the line, I embarked on a quest to redefine what "women with skin of color" means to black, Latina, Asian, Native American, Mediterranean, and Middle Eastern women, and all the other women of the world. I wanted the line to cater specifically to skin of color. I conducted a series of interviews with diverse women—from all ages, occupations, and walks of life—and I found that their cosmetics needs were identical to mine. Flawless foundations that flattered—not altered—our skin tones, products for two-tone lips, SPF-infused skin-care (the sun does not discriminate, ladies), and the ultimate bronzer—yes, bronzer: Skin of color also looks gorgeous with a sun-kissed sheen! We wanted a celebration of our skin. We wanted makeup that celebrated our ethnicity.

In 1994, I launched IMAN Cosmetics, and it became an instant success with beauty editors, makeup artists, and celebrities. But most important, it was a success with everyday women.

Today we're embarking on a new era, when the most celebrated beauties in the world are women with skin of color: Halle Berry is, indisputably, the most beautiful woman in Hollywood; Jennifer Lopez has the most coveted bronzed glow ever; Lucy Liu has that magnificent elegance with a touch of tomboy freckles; and Cameron Diaz is the ultimate, high-voltage, bubbly California girl!

Although my makeup was an inspiration for starting this book, that's not what the following pages are about. Instead, my hope is to offer a singular and original look at the beauty of skin of color—in its various shades and origins. Here, you'll find how to choose the right foundation for you. How to go from classic to vampy in minutes. How to come to terms with the high-maintenance diva that you are. How to turn age-old makeup rules inside out by wearing traffic-stopping glitter for day, and a fresh, bronzy face at night. Anything and everything goes.

Make up your own rules.

In this book, I hope you'll find ideas for using makeup as self-expression, and easy help for improving the way you look and empowering the way you feel.

1 SKIN CARE

How to Create a Flawless Canvas

There is no denying it . . . great makeup looks even better on beautiful skin. So when it comes to your complexion, cleanliness should be next to godliness! In Western society, women start paying attention to skin care way too late. In Africa, I was taught that the skin you take care of in your teens and 20's is the skin you'll inherit in your 30's, 40's, and beyond. And just so you know, my mother looks incredible and hasn't gone anywhere near a Botox needle.

"I do the normal, ordinary routine—you know, wash my face before I go to sleep, brush my teeth three times a day. But I think when you're happy it shows."

—Michelle Yeoh, Malaysian, actress and martial artist

Skin Type

Let's start this section by getting a few things straight, shall we?

Women with skin of color tend to have oily skin—but not all of us do! Just as black, Asian, Latina, Mediterranean, Middle Eastern, and Native American women come in all shapes and sizes, we can also have any number of skin types. What we do have in common is that we don't tend to wrinkle as much as white women. But it's a myth that this is because we all have oily skin. It's primarily because the melanin in our skin acts as a natural barrier to the ultraviolet rays that cause wrinkling. And, well, it's our genes, too.

It's normal for your skin to change throughout the year.

Skin is extremely susceptible to outside factors—the season, your diet, whether or not you smoke, whether you live in an arid, humid, or highly polluted climate. It can also change with your period, if you're pregnant, or when you're stressed. Don't fret—you'll just need to tweak your regimen a little.

Most important, hardly anyone has just one skin type.

A woman with oily skin might also have sensitive skin; someone with dry skin might also have acne-prone skin. Diagnosing yourself as one type and buying a whole line of corresponding products is a very old-fashioned way of approaching skin care—and it's not effective. Really look at the way your skin behaves. If you have acne but your skin is dry, normal oil-absorbing acne products will irritate your skin. All your symptoms should be taken into consideration when you choose products. Now, here are the major skin types; you can mix and match to find your perfect diagnosis.

Iman, Somalia

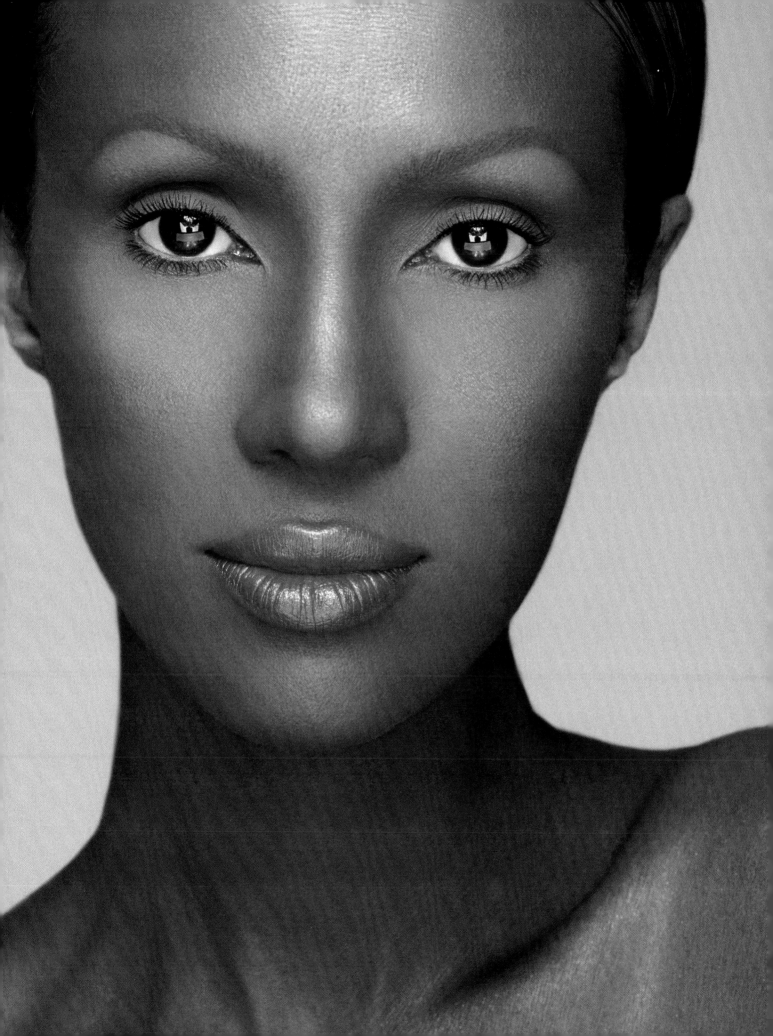

Oily Skin
Ways to tell if you have it:

Are you prone to pimples, blackheads, and whiteheads?

Do you have large pores?

Does your face look shiny when you wake up, especially in the T-zone?
The T-zone is the area across the forehead and down the nose, to the chin.

Does your foundation wear off after a couple hours?

In a nutshell:
Your skin tends to overproduce sebum, making it feel and appear oily.
This is a good thing, actually, because it means your skin is always well
moisturized, and you'll have fewer wrinkles as you age. On the other hand,
you're more prone to breakouts, since sebum has the tendency to mix with dead
skin cells in your pores; this clogs them and produces pimples.

Dry Skin
Ways to tell if you have it:

Does your skin feel itchy or tight, especially after cleansing?

Do you have rough, flaky, or red patches?

Did you make it through adolescence with no acne?

Are you sensitive to the sun, wind, and cold?

Does your complexion look dull?

In a nutshell:
Dryness occurs when your skin doesn't produce enough moisture and sebum.
This can happen if you live in an arid climate, because the dry air saps the
skin of its moisture. You can also experience dryness because of artificial heaters,
sun overexposure or chlorine from swimming pools. Dryness can make your skin
look great—with fine pores and a clear surface—but it can also be uncomfortable
and make your skin rough to the touch.

Combination Skin
Ways to tell if you have it:

Are your cheeks dry, but your T-zone oily or pimple-prone?

Are you oily or pimple-prone along the perimeter of your face, but dry everyplace else?

Do products that help one part of your face hurt another?

In a nutshell:

Many of us have combination or unbalanced skin, since the T-zone naturally contains more oil glands than the rest of the face. Also, using the wrong products can result in skin that's drier in some places and oilier in others. Maybe you should stop using toner—harsh astringents can be very dehydrating. Or switch to a light, oil-free moisturizer to prevent breakouts. It's all about experimentation.

Sensitive Skin
Ways to tell if you have it:

Does your skin irritate easily?

Is your skin often red or blotchy?

Do you have allergic reactions (stinging, itching, burning, etc.) to certain beauty products?

Do you sunburn easily?

Do you have broken capillaries beneath the surface of your skin?

In a nutshell:

Any skin type can be diagnosed as sensitive, since it's nothing more than a negative reaction to outside factors, like wind, sun overexposure, allergies to certain products, and overzealous scrubbing (and who isn't guilty of this from time to time?). The thing to do is notice how your skin responds to things, and use the gentlest products possible.

Hyperpigmented Skin

Ways to tell if you have it:

Do you have dark spots from bug bites, pimples, or rashes that won't go away?

Do you freckle easily in the sun?

Do you have dark moles?

In a nutshell:

This is common among black, Latina, and Middle Eastern women. Truth be told, it's the bane of our existence! Hyperpigmentation is a darkening of the skin in patches or all over, and is most often caused when skin has undergone some trauma that causes inflammation (acne, burns, chemical peels, laser treatments, sun overexposure, and so on). When the inflammation subsides, the skin is left with a dark mark. Sometimes the marks go away on their own, but more often the fading process can take months or even years. More on this later.

Normal Skin, or "My Complexion Is Naturally Flawless"

Ways to tell if you have it:

Does your skin always feel and look supple, with or without moisturizer?

Do you have few or no breakouts?

Can you use almost any product without irritation?

Is your skin tone even, without any darker or lighter areas?

In a nutshell: **Lucky you!**

Cleansing

The sooner you figure out which cleanser is right for you, the faster you'll have
the soft, supple, young-looking skin you want. With the never-ending assortment of cleansers
on the market, choosing the right one is akin to speed-dating. But at least
if you go home with the wrong cleanser, you can throw it away!
I hope this guide makes things easier.

Find the Right Cleanser If You're:
Oily

How can I make you understand that oily skin is not dirty skin? The two are as mutually
exclusive as a trendy restaurant and good service! Women with oily or acne-prone skin are apt
to scrub a little too enthusiastically, using harsh soaps. In doing that, they strip the skin of its
natural oils, causing the oil glands to panic and overproduce sebum—ultimately leading to
breakouts. Skip the scrubbing and the soap, please! Instead use an oil-free gel or foaming
cleanser—either will remove excess oil and dirt without dehydrating your skin.

Still feel oily after cleansing?
Clear out your pores further by steaming your face. Follow this simple recipe:

· Bring three cups of water to a boil. Pour into a bowl.

· Add about five drops of your favorite essential oil. For those of you who are late to
 the aromatherapy party, essential oils are concentrated extracts of plants that come
 in a variety of heady, delicious scents. You can buy them at beauty, bath,
 or health-food stores, and online.

· Drape a towel over your head and the bowl, and let the steam envelop you for five to
 ten minutes.

· Rinse your face with cool water.

Dry

To avoid that tight, parched feeling you can get after washing your face, use a rich,
cream-based cleanser containing emollients like fatty acids or glycerin. After rinsing,
pat dry with a soft washcloth, and leave your skin slightly damp. If your skin is
super-dry and flaky, try a tissue-off cleanser—it leaves a thin layer of moisture on the skin.

From lef:: Theresa, Barbados; Yasmin, Somalia; Song, Korea

Combination

Don't err on the side of dry *or* oily skin—stick to cleansers formulated specifically for combination skin. These ultra-gentle cleansers will help balance your complexion, perfectly prepping it for your moisturizer.

Sensitive

Go for a thin cleansing lotion that's hypoallergenic, allergy-tested, or fragrance-free. However, keep in mind that the claim "fragrance-free" can be tricky. Just because the cleanser doesn't have fragrance *added* to it doesn't mean that it's without a distinct scent. Try the cleanser only on your neck for a few days. If it irritates your skin, try something even milder. Many pros sing the praises of "all-natural" or "organic" cleansers for sensitive skin—but are they really more gentle on your skin? Not necessarily; each one is different. But they're worth a try!
Here, a mini-guide to the most popular natural ingredients out there:

Moisturizers: olive oil, shea butter, avocado oil, honey, milk (lactic acid)

Skin-soothers: aloe vera, lavender, chamomile, geranium, green tea

Oil-fighters: tea tree oil, citrus (lemon, orange, bergamot), ylang-ylang, rosemary

Hyperpigmented

The best cleansers for you are those that exfoliate, because they slough off the top layer of skin, along with dark marks. Avoid cleansers containing manual exfoliators like micro-beads, salts, ground nuts, and so on—they can cause irritation, which leads to more dark spots. Instead, look for those containing glycolic acid, which do the job *gently*.

Normal

The great thing about normal skin is that you don't need to pick a formula that *fixes* anything! Go for an SPF-infused cream cleanser or a pack of disposable cleansing cloths for normal skin (so refreshing and great for the gym if you're a no-fuss type). Just make sure your cleanser leaves you feeling supple, not tight.

Lies, Lies, All of Them!
Debunking cleansing myths

Myth 1:
Sleeping with your makeup on is okay, because when you wake up you'll have that smeared, smudged, my-night-was-too-fabulous-to-bother-with-skin-care look that's very hot right now.

Truth:
Do you want foundation, concealer, and blush sinking into your pores overnight, causing breakouts? Not to mention the infections that can result from eye makeup being trapped under your lids all night. Please, ladies—create the "elegantly wasted" effect with hastily applied mascara in the morning.

Myth 2:
The more expensive your cleanser is, the better it is for your skin.

Truth:
So not true. Does the cleanser make you dry? Greasy? A Bill O'Reilly fan? If so, it's the wrong one, no matter how much it costs. Whether your cleanser costs $10 or $100, what works for you is the best choice.

Myth 3:
Splashing off your cleanser with cold water tightens your pores.

Truth:
Huge urban legend, the idea that pores can actually expand or shrink. The pores themselves don't budge—however, they're more visible when filled with dead skin and dirt (here's a secret: pore-minimizing products simply clear out debris, making pores less visible). The cold water thing? It just feels tingly and invigorating, and so it makes you feel like something special's happening. But lo, no.

Moisturizing

As a general rule, we should never, ever let our skin get too dry. When we get flaky, patchy skin, it can lead to dark spots that take *forever* to go away. So ladies, keep your skin hydrated and happy. Of course, if your cleanser leaves your skin feeling moist and supple, or if you have very oily skin, you can pretty much call it a day after you cleanse. If not, listen up!

First Things First

The skin on your face is delicate—it's not like the skin on your body. So, the way you apply body lotion doesn't fly when we're talking about moisturizer. I wouldn't go so far as to call it an *art*, but there is a certain level of technique involved.

1. Apply moisturizer when your face is still damp from cleansing.
 This will prevent the water from evaporating.
2. Dab it on with the pads of your fingers.
3. Gently massage in the moisturizer with upward strokes.
 Don't rub, tug, or pull!

Find the Right Moisturizer If You're:

Oily
Unless you're using acne medication that leaves you flaky, you probably don't need moisturizer. In the acne-meds case, use a gel or serum formula only on the dry areas. Or, use a moisturizer containing salicylic acid or benzoyl peroxide, all over.

Dry
If your skin is dry or flaky (or both), go for a rich cream formula—avoid gels, lotions, and serums. Look for ultra-hydrating ingredients like shea or cocoa butter, avocado oil, and lanolin. Keep in mind that even dry skin can break out, so if you're acne-prone, try an oil-free moisturizer.

Combination
To avoid aggravating both your dry and oily areas, stick to a light skin-balancing lotion or hydrating toner.

Sensitive
Stick to light, oil- and fragrance-free formulas containing skin-soothing ingredients like aloe vera, chamomile or vitamin E, to calm down an irritated or reactionary complexion.

Hyperpigmented
Yes, even women of color need SPF. First of all, we do get skin cancer—not as often as fair-skinned women, but it happens. On an aesthetic level, sun overexposure can give you dark spots, freckles, and patches. Prevent this by always wearing an SPF-infused moisturizer. To treat existing spots, at bedtime apply a fade cream containing hydroquinone, retinol, or glycolic acid over the dark area (not all over, or your skin could become blotchy). If the marks don't fade with over-the-counter treatments, consult a dermatologist.

Normal
Try a lightweight tinted moisturizer. Think of it as the skin-care equivalent of Ashanti: light, uncomplicated, pretty.

2 MAKEUP 101

What You Really Need, Nothing More

Makeup is like magical fairy dust—done right,

it can change your entire persona in seconds.

You could be a smoky-eyed vixen one night, a dewy,

rosy-cheeked ingénue the next. The best part?

The right tones can make you look so naturally flawless

that no one will believe you didn't wake up that way.

My advice? Don't argue!

"I wasn't allowed to wear makeup until I was fifteen. I'd bite my lips or rub my mom's lipstick on my cheeks. I'm not the glamour girl who wears makeup every day. I just know what to wear to make me look good."

—Salma Hayek, Mexican-Lebanese, actress and producer

Using the right makeup tools is essential.

It can make the difference between looking unpolished and looking flat-out fabulous. I could launch into a lengthy "what's a brilliant painter sans brilliant brush?" metaphor, but you get the picture. Here's everything you need to know about the tools of the trade.

1. Powder brush: A fluffy, oversized brush used to dust on loose powder or bronzer.

2. Blush brush: A round, medium-sized brush used to apply and blend blush or bronzer.

3. Foundation brush: A large, flat, oval brush used to apply liquid or cream foundation. Usually made of synthetic fibers.

4. Wedge sponge: Used for applying and blending foundation. Can be used dry for a matte finish, or wet for a dewier look.

5. Smudge brush: For a soft or smoky look, trace it back and forth along eyeliner, blurring it out a bit.

6. Shadow brush: A fine, flat brush used to highlight the browbone, accentuate the crease, or sweep color all over the lid.

7. Brow brush: A firm, angled brush used to sweep color onto the eyebrows. Don't go crazy with this, or you risk looking like Joan Crawford.

8. Liner brush: A stiff-bristled brush used to trace an exact line along the lashes.

9. Eyelash separator: Use to comb through mascara'ed lashes to get rid of clumps. Rinsed clean, it's great for blending in brow pencil.

10. Lip brush: A tiny brush used to apply lipstick or gloss—gives great definition. Also fantastic for applying concealer.

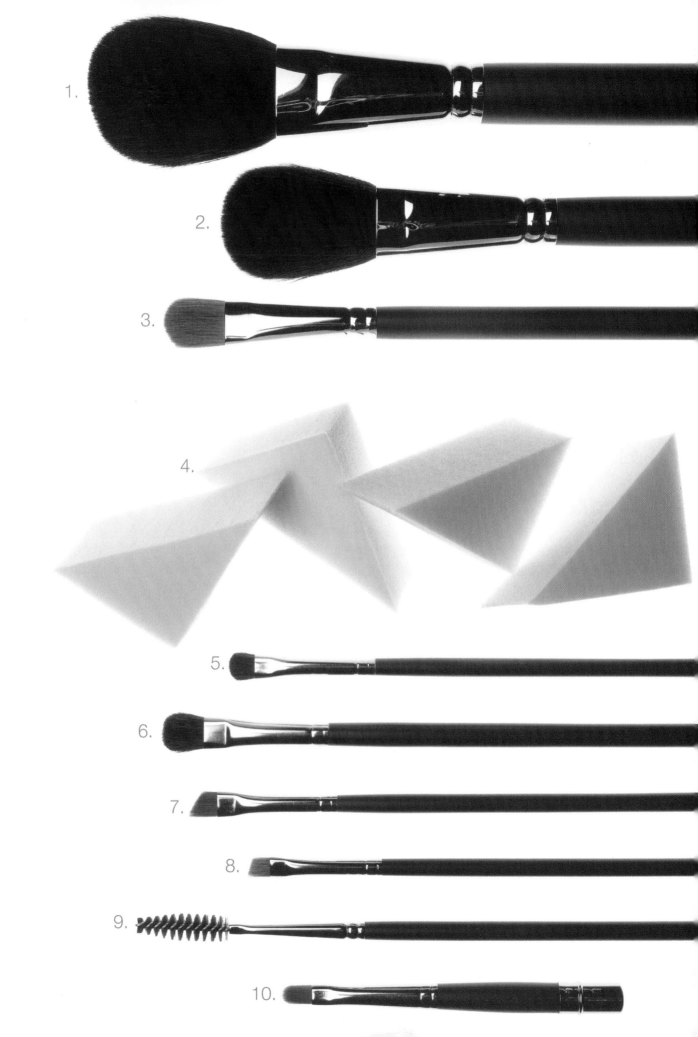

1.

2.

3.

4.

5.

6.

7.

8.

9.

10.

foundation

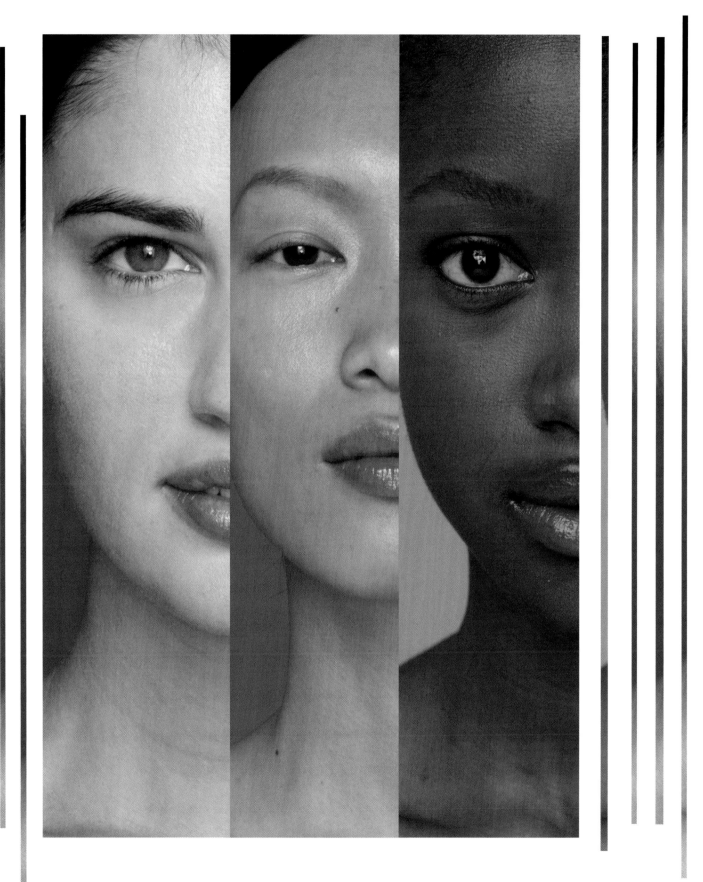

foundation

One of my first modeling jobs was for *Vogue*, with a very famous makeup artist who shall remain nameless. I didn't know anything about makeup, so I totally trusted his expertise. After he finished my face, I looked in the mirror and was shocked to see the face that stared back at me!

My skin was gray, and the rest of my makeup was awful, too. The thing is, makeup is all about foundation. It'll throw everything else off if it's wrong. And if it's right, you can get away with *anything*. Despite looking disturbingly alien to myself in the mirror, I was such a newcomer that I thought maybe I'd come out different in the photo. I didn't. The photo was terrible, and I was horrified. You see, in my business when a photo of a model turns out unflattering, no one will say the makeup artist wasn't good—they'll blame it on the model. It dawned on me then that I'd have to figure out how to create my own foundation. I wasn't willing to allow a makeup artist to alter or misrepresent my skin color—and most of all, my ethnicity—especially at a time when so few black models were given the opportunity to shine. As Oprah commented once to Sudanese model Alek Wek, "When I was growing up, if you'd been on the cover [of a magazine] I would have had a different concept of who I was."

The next day, I went out and bought a bunch of foundations, sat down in front of the mirror, and practiced. I mixed and matched the shades until I created the right one, and then I took Polaroids to make sure my skin came out right—a beautiful chocolate brown, not red, gray, or ashy.

I became a foundation expert.

As I climbed the ladder of success in the modeling industry, armed with gorgeous photos of my natural brown skin, it was a triumph for me. But most of all, it was a triumph for young women with skin of color who saw that yes, we are beautiful.

What do women want in a foundation? Flawless, natural-looking coverage.

There are so many different textures, consistencies, and formulas . . . it's not your grandma's thick, opaque face makeup anymore. The new foundations manage to hide iffy areas while allowing your skin to show—making you look like *you*, just a more beautiful, radiant you.

Still, many of us are scared of foundation—the word just sounds so uncomfortably repressed, like "foundation garment." It makes you think of being corseted, but not in a fabulous, Thierry Mugler kind of way—more in an "I'm slowly suffocating" way. If this is how you see things, it stops now!

Foundation is your friend! But as with matters of love, career, and the perfect jeans, you just have to find the right fit.

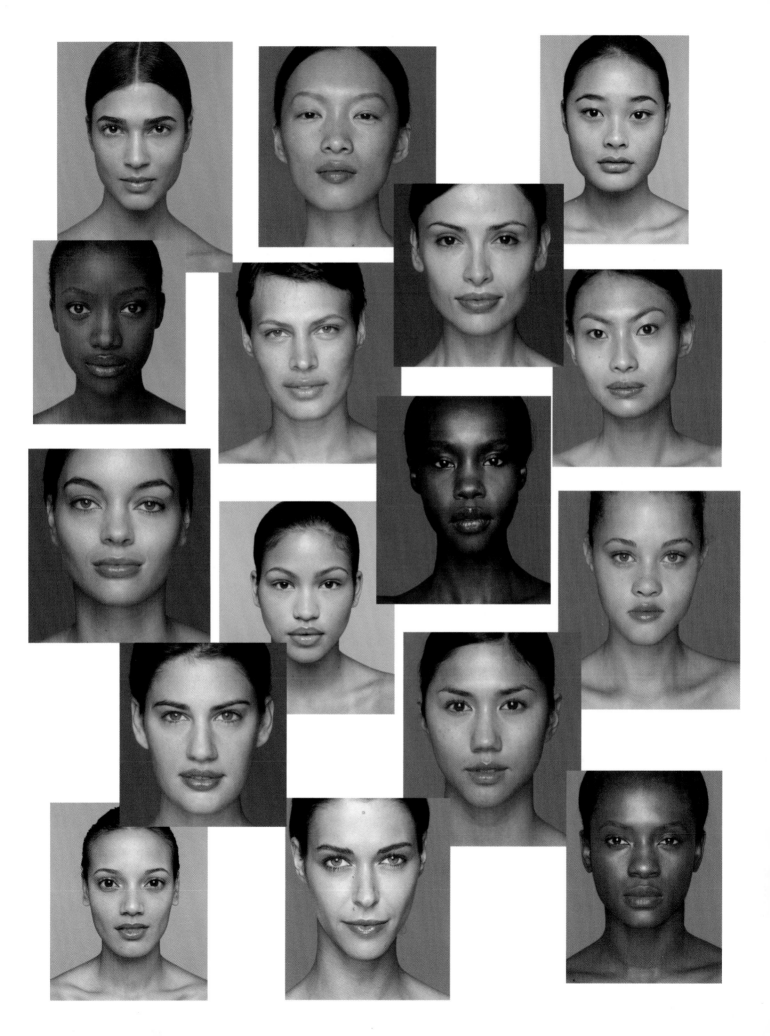

Get Complexion Perfection If You Have:

Hyperpigmented skin or acne scars:
Go for a stick or cream foundation. They perfectly camouflage discoloration, while blending to a natural-looking, creamy finish. Most blend so seamlessly that you rarely need concealer.

Minor spots you'd like to keep mum:
Try a full-coverage liquid foundation or a cream-to-powder formula. Slightly less coverage than a stick, but still great for hiding trouble areas.

Good skin but want extra polish:
You want a sheer liquid foundation or a tinted moisturizer. Either provides ultra-light coverage with just a hint of a tint.

Oily or acne-prone skin:
Oil-control liquid foundation is a must-have: It prevents midday greasies, and leaves you with a clean, matte finish.

Combination skin:
It's all about a balancing liquid foundation, which makes the T-zone matte and hydrates drier areas like cheeks, forehead, and chin.

The desire to fake a radiant, my-night-was-better-than-yours glow:
You must use iridescent, illuminating liquids or sticks. They don't hide, they highlight. Dot and blend along cheekbones, bridge of nose, forehead, and chin.

Testing, Testing

Three Foolproof Steps for Trying on Foundation:

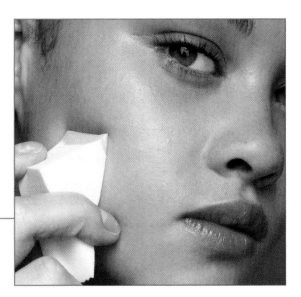

Step

1
First, pick three shades to try: one that looks about right, a lighter color, and a slightly darker one.

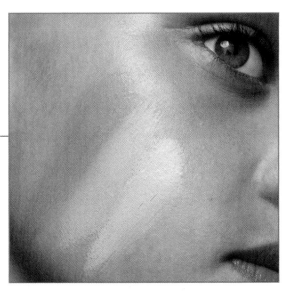

Step

2
Swipe each one on your jawline.

Step

3
The shade that disappears or perfectly matches your skin is the one!

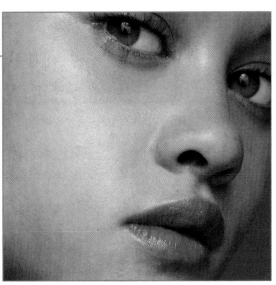

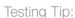

Testing Tip:
Don't ignore the rest of your body—your face isn't a separate entity. Compare the shade to your neck. Does it match? Foundation should reflect the color you are all over. If you're still on the fence, have the beauty professional at the counter apply the foundation on you (or ask for samples), and wear it all day—how does it look in daylight? Artificial light? Does it run, separate, or get dry, patchy, or oily? Some things to think about . . .

ColorWheel

There's a misconception about women with skin of color that I'd like to clear up once and for all. It would be easy to break up skin color like this: Asians have porcelain skin, Latinas are olive-skinned, Middle Eastern women and Native Americans are bronze, and blacks are dark-skinned.

But it's just not true. Never let anyone put you in a box! Some Latinas could easily be mistaken for Middle Eastern, and some black women are lighter than Asians. And biracial and multiracial women have a varied range of hues and features, each one totally unique!

So I'm going to address your skin color, not your "ethnic" color, because there's really no such thing.

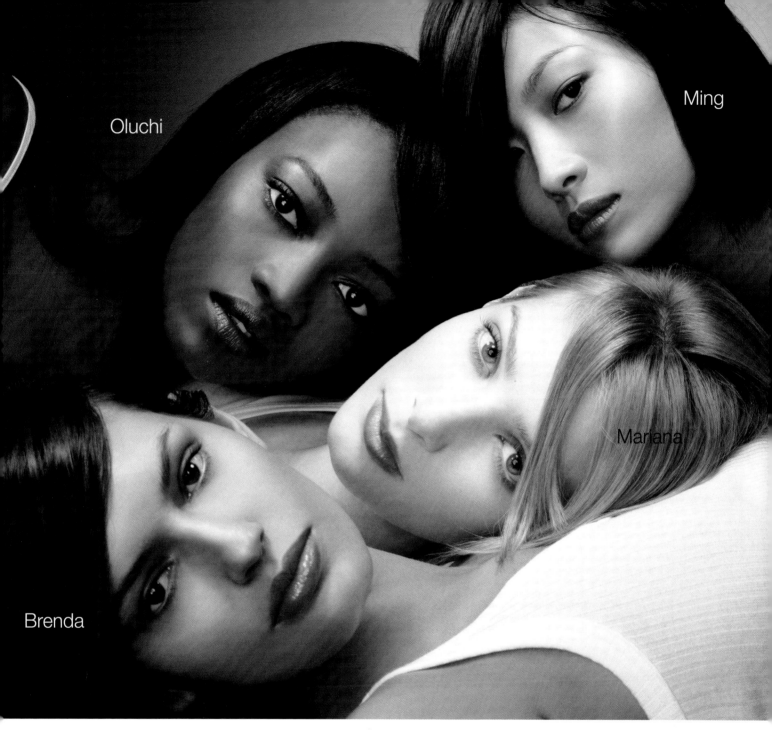

Oluchi

Ming

Mariana

Brenda

The Next **BIG** Thing

Soft-Focus Foundation

Instead of coating your skin with color, these sheer formulas contain fancy light-reflecting pigments and optical diffusers that soften the appearance of fine lines, making you look as if you've been airbrushed to perfection.

Oluchi, Nigeria
She's wearing two different stick foundations. Dark-skinned women should rarely wear all one color—like Oluchi, they're usually lighter in the center of the face, and darker around the perimeter.

Ming, China
To camouflage some uneven spots, she's wearing a full-coverage liquid foundation in a golden-tawny shade.

Mariana, Brazil
To warm up her very fair, rosy skin, she's wearing a neutral-toned, sheer liquid foundation.

Brenda, Brazil
For a finished look, she's wearing a touch of sheer liquid foundation to match her tan complexion.

concealer

Concealer

All the cucumber slices in creation couldn't fix my puffy undereye circles. Why? They're genetic (I say with not a smidgeon of bitterness). Suffice it to say, I depend heavily on concealer. In fact, if I do nothing else, I apply concealer under my eyes. It's simply the easiest and fastest way to look radiant, healthy, *awake*. If you're a chronic partyer, an insomniac, or have acne scars—or if undereye circles were innocently passed on to you by your dear mother, ahem—pay attention.

Here's how to cover up:

Undereye Circles

First, make sure you're facing your light source, so you don't get shadows and end up applying concealer to dark spots that don't exist! Masking undereye circles calls for full coverage, so use a cream concealer or foundation stick. To apply, use a tiny brush to paint on concealer from the inner corner of your nose to the outer corner of your eye. Then blend, woman, blend!

Dark Spots and Patches

Hyperpigmented skin needs even fuller coverage than undereye circles.
Look for a highly pigmented, dense concealer. With a wedge sponge, apply over the dark spots with a patting-rollling motion. Then blend on a foundation shade that's lighter than your skin but darker than the concealed spot. Tricky, but with practice, totally doable and, more important, worth it.

Pimples

There are a bunch of salicylic acid–infused concealing sticks and creams on the market for acne sufferers. It's a brilliant idea—now you can cover up your blemishes while imparting medicine to clear them up. The important thing to remember, though, is that salicylic-acid formulas should never be used under your eyes, only on blemishes.

Blending Basics

1. To warm up your concealer, swipe some on the back of your hand. Then use a tiny brush to pick up the concealer and apply—it'll blend like a dream.

2. Choose a concealer one shade lighter than your natural skin color. If it's too dark or too light, it'll look unnatural and actually highlight the area you're trying to conceal. Here are the shades to use if your skin is:

 Light olive to olive: warm beiges
 Deep tan: sandy neutrals
 Dark: caramels
 Very dark: warm cocoa

3. As with foundation and powder, always use a yellow-based concealer, no matter your skin color. It's the most natural-looking.

4. If you're fair-skinned, try a wand concealer; it has the sheerest formula and won't overpower your skin tone. If you're medium- to dark-skinned, try pots, sticks, or creams—you'll need a concealer with more pigment, since you have more pigment in your skin.

Role Reversal

If you wear concealer and foundation, try putting on the foundation first.
Why? You may find that it adequately covers the areas you were going to conceal.
If you still look uneven, then add concealer, and set with powder.

Ana Paula, Brazil

powder

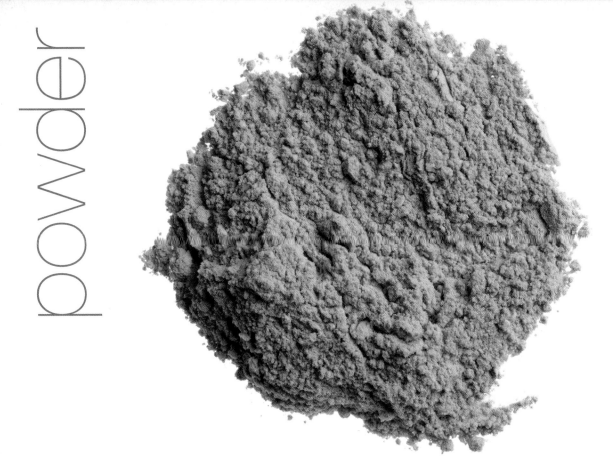

Powder can be so glamorous. It calls to mind a Harlem Renaissance party girl poised at her vanity, dabbing at her nose with a fluffy puff before a night of cocktails and kisses. Nice, right? Of course, if you get the wrong shade (and put on too much of it), powder can also call up images of your blowsy great-aunt who smokes Newports and wears lipstick outside the lines.

For women with skin of color, it's so, so important to get the shade and tone right. If it's wrong, you can look incredibly ashy, or like an Oompa Loompa. Here's the secret: Always use a powder with a yellow undertone.

No matter your skin color, a yellow-toned powder always looks the most natural, healthy, *radiant*.

Best of all, even if the shade is a little off, the powder won't clash with your skin and look artificial. If you have very dark skin, however, it's more important for the color to be right than the tone. Also, no matter what shade or formula you use, always apply it with a light hand. Use powder delicately, sparingly!

Nina, Ivory Coast

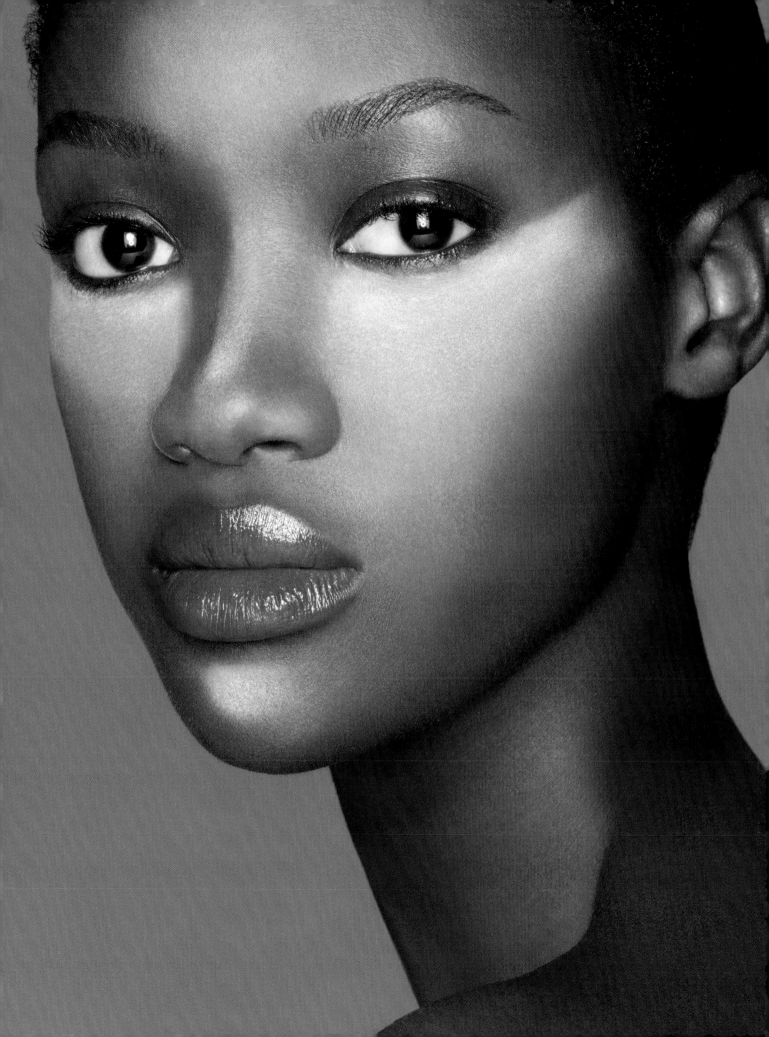

The Powder Principle

Powder serves two major purposes: It's used to set foundation and to control shine. If you wear foundation or concealer, it's always a good idea to set it with powder. This will keep it from slipping, settling into fine lines, or wearing off. To set, lightly press powder onto your face with a puff, or dust on a loose powder (in a matching shade or translucent) with a powder brush. If you don't wear foundation but want to control shine, press powder onto your T-zone with a powder puff. Whatever you do, always press, don't rub—and keep it as sheer as is humanly possible!

What Kind?

The type of powder you use depends on the look you want.
Here, the most popular types:

1. Translucent: It's totally colorless, and can be used on all skin tones. Great for setting concealer under your eyes or around your nose—pigmented powder can make the area appear darker.

2. Pigmented: Can be used alone, for a fresh, clean look. If you're using it to set foundation (for extra coverage and a matte appearance), make sure the powder is one shade lighter than the foundation, or your skin will darken and look patchy.

3. Powder foundation: The best of both worlds, this opaque formula offers full-coverage and an even, satiny finish while keeping shine under control. Applied with a wet sponge, it can also be used as a sheer foundation. If you have oily or acne-prone skin, make sure it's oil free and non-acnegenic.

4. Illuminating: These sheer powders usually have light-reflecting properties and a slight shimmer to give skin a luminous, soft-focus effect. Use over foundation or alone. Illuminators enhance wherever they're applied, so if you have a flat nose or round cheeks, add dimension by swiping the powder down the bridge of your nose and cheekbones.

Loose Versus Pressed

Loose is sheer, pressed more opaque. If you're just looking to control shine, dust on a bit of loose powder with a fluffy brush. If you need heavier coverage to even out your skin tone, or to make sure your foundation doesn't head south by two a.m. pat on an oil-free pressed powder.

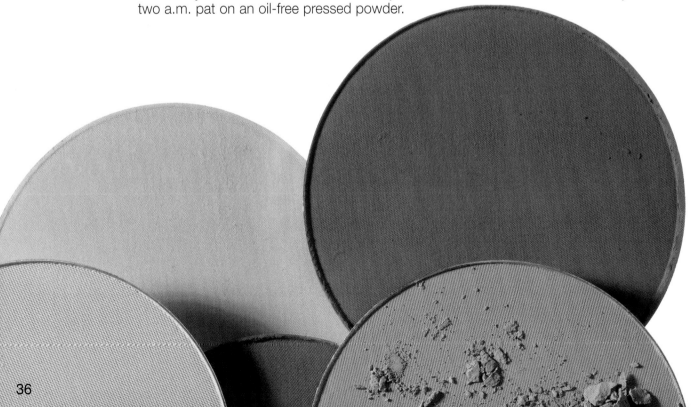

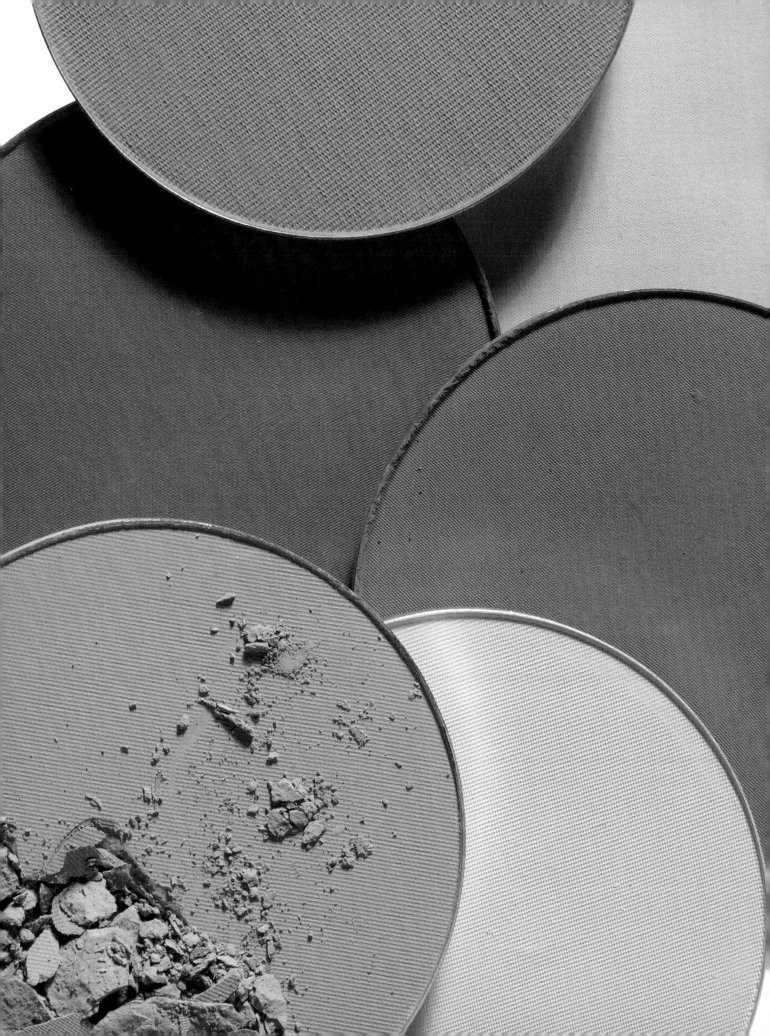

Witness the power of bronzed skin: Beyoncé, dewy, shimmery, and glowing in the "Crazy in Love" video; Lucy Liu, all freckles and beachy/tawny cheeks in *Charlie's Angels*; Jennifer Lopez . . . well, Jennifer Lopez just existing. If you see photos of Jennifer from the start of her career, she looks markedly different from how she looks now—still beautiful, to be sure, but she had a milky, almost porcelain complexion. I'm sure there's no relation, but doesn't it seem that she didn't become *J.Lo, International Superstar* until she embraced the bronze? So what is it about sun-kissed skin? Maybe it calls to mind cavorting about on a beach, which is always sexy. Maybe it's that bronzer seems to even out skin tone, making it appear flawless. Whatever the case, it's fabulous, and here's how to make it work for you.

From left: Lisa, USA; Yamilla, Argentina

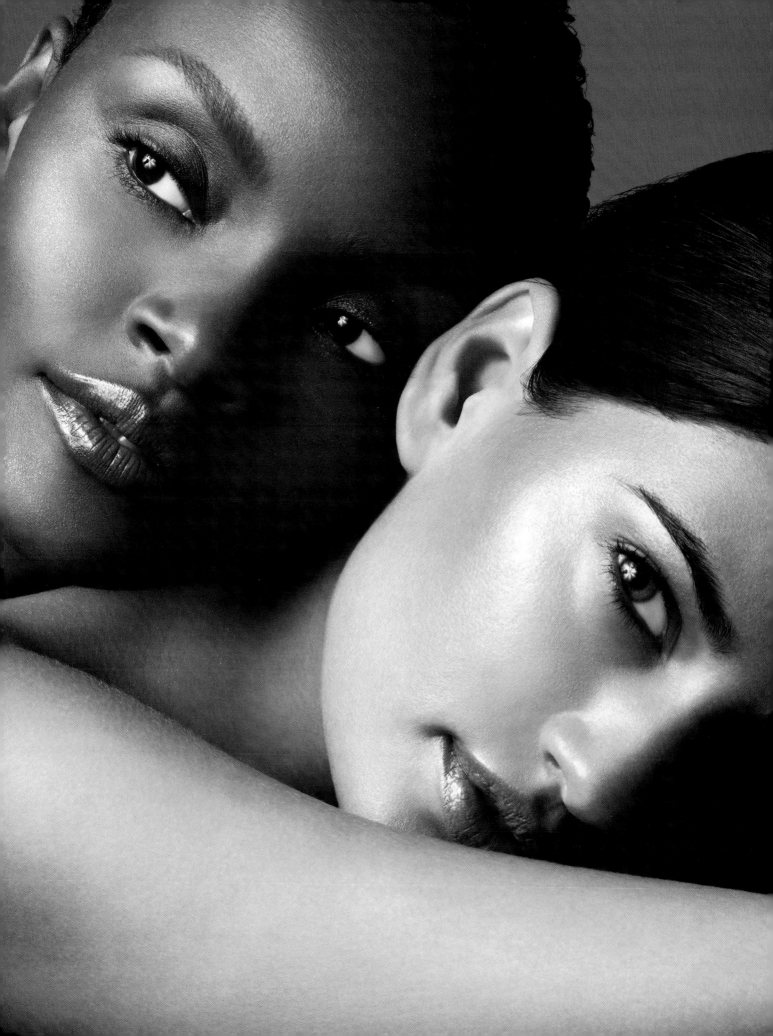

Bronzer Tips

1. First, make sure your face is clean, dry, and matte. Bronzer will stick to oily or damp areas and streak, making your face look dirty.

2. Women with skin of color always need to apply blush before bronzer. Why? Well, since we're already brown, most bronzers wouldn't show up on us. But if it's blended over a rosy blush, it'll not only be visible, but the rosy-bronze combination gives an impossibly sexy, slightly sunburned look.

3. Want a dewy look? Dab a sheer gel bronzer over gel blush, or blend a bronze highlighting stick along your cheekbones.

4. When going for a sun-kissed look, apply bronzer with a big fluffy brush, and concentrate on the areas where the sun naturally hits your face— cheekbones, bridge of nose, and forehead.

5. Use a light hand. If you're light-skinned, overdosing on bronzer is a mistake of George Hamiltonian proportions.

ColorWheel

The right shade if your skin is:

Light olive to olive: tawny or honey

Deep tan: true bronze

Dark: true bronze with gold shimmer

Very dark: metallic copper and deep bronze

Oluchi, Nigeria

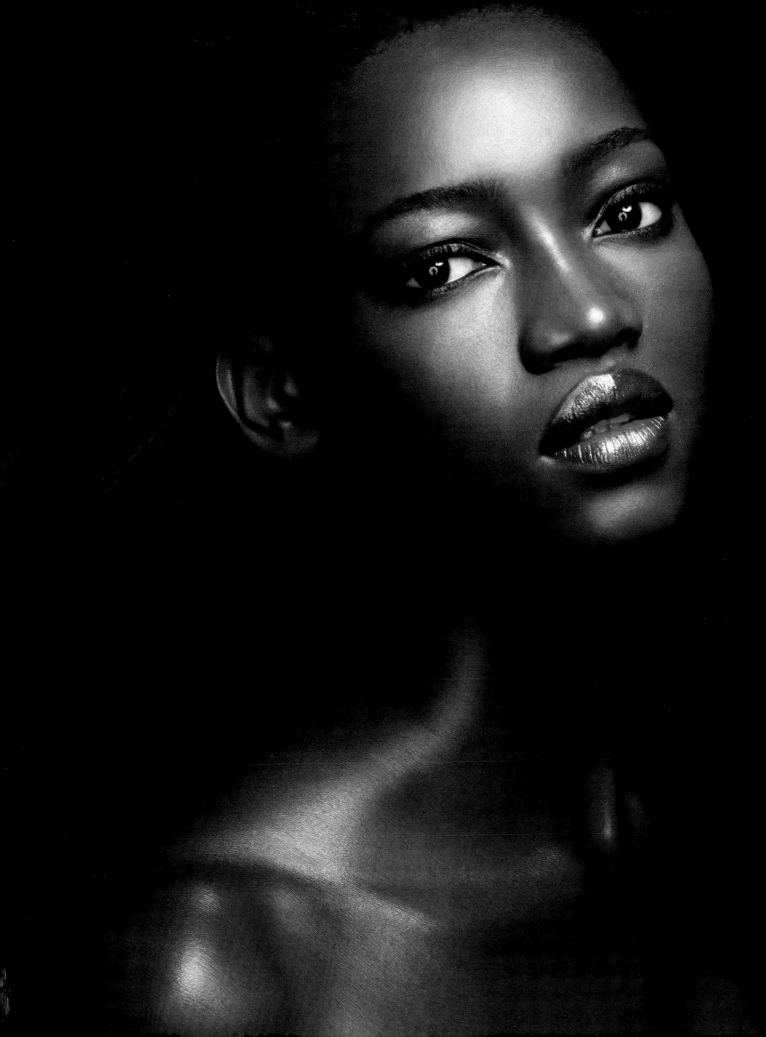

So many women with skin of color abandon the whole blush thing because for so long it's been as difficult as AP-level Calculus to find shades that work. Worry no longer. I'm here to help with some friendly advice and a few gentle rules:

1. I don't want to hear your excuses, and I don't care what color you are. We're going to find your shade, ladies. Forget AmEx—never leave home without blush.

2. Women with skin of color come in a zillion shades, but here's one constant: Any blush with a bit of gold shimmer looks fabulous on you. It instantly brightens your face, and makes you look like you've just returned from Ibiza.

3. The modern way to wear blush is right on the apples of your cheeks—it gives such a sexy, breathless, après-ski look. But if you have a round face, instead swipe a champagne-colored powder along your cheekbones and blush just underneath—this gives the illusion of dimension.

ColorWheel

Find the right shade if your skin is:

Light Olive to Olive

If you're naturally rosy, adding a true pink blush is a no-no. Instead, warm up your complexion with pale apricots and peaches or sheer coral.

Deep Tan

If you're medium- or olive-skinned, you probably have a tendency to look sallow. Balance out your complexion with deep true pinks, tawny roses, and sheer cherry stains.

Dark

Add a deep flush to your skin with shimmery cinnamons, bronzes, or even true Crayola orange. Believe it or not, it's so beautiful—when applied to the apples of the cheeks, it gives a gorgeous flush.

Very Dark

Many women with deep coloring think it's impossible to get a natural-looking flush. Not true! Deep berries, velvety crimsons, and gold-infused plums look absolutely stunning.

And if all this is too complicated, just find the shade your cheeks turn when you blush.

Texture Wars

Whether you choose a cream, powder, or gel stain depends on your skin and the look you're going for. If you're in a breathy Victorian mood, then go with a stain. Working a steamy, dewy, Rita Moreno–in–*West Side Story* moment? Dab on a cream blush. And if you want a clean, matte finish, use the classic powder formula. That said, here's what's ideal for your skin type:

Oily: Stick with oil-free, water-based stains. Avoid powder blush; it'll go on uneven and look streaky, and creams will appear greasy.

Dry and flaky: You're probably using a heavier moisturizer, so a cream formula would blend in most naturally.

Normal: You can use anything—so get your blush on.

Selita, Cayman Islands

eyebrows

Perfectly arched brows can work all sorts of magic on your face.

Miraculously, your eyes will look bigger and brighter, your cheekbones more defined, your face thinner. In fact, the only thing good brows won't do for you is your taxes. But, as UGG boots and *Matrix* sequels have proven, it is entirely possible to get too much of a good thing. Tweezing is no exception. It's an addiction, and overdosing can make you look like, well, a hoochie (oops, was that indelicate?). I'd suggest you get them professionally waxed or plucked for the first time, to establish the shape. Then you can take matters into your own hands.

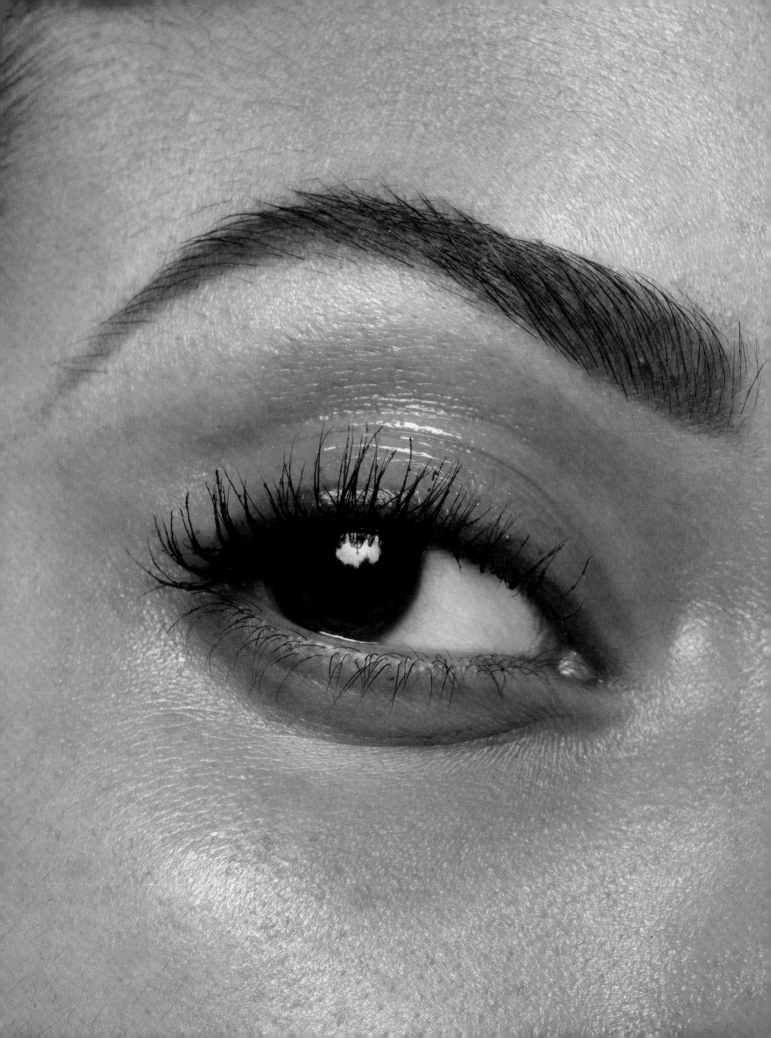

How to Get the Perfect Shape

First, ignore what eyebrow shape is trendy at the moment. Who doesn't look back on those early-90's-grunge brows and cringe? Think "polished" and "pretty"—you can't go wrong.

To find the right shape, line a pencil vertically alongside your nose. This is where the brow should begin. It should end just a smidgen past the outer corner of your eye.

The biggest brow mistake is plucking too much underneath the beginning of the brow. This looks so unnatural! Look straight ahead—your arch should begin directly above your iris.

Look at some celebs whose face shape is similar to yours, and copy. Halle Berry, Ashanti, Eva Mendes, and SuChin Pak, to name a few, have some truly inspirational brows.

Once you've established your ideal brow shape, begin tweezing underneath and, if you're taming a unibrow, between your brows. To pluck, grab the hair at the root and pull in the direction of hair growth.

Don't tweeze above your brows! You risk not only ruining your arch but also looking terrified for the next month.

If you have curly or wayward brows, keep them in place all day by sweeping on a clear brow gel in the direction of hair growth.

If all of this is too complicated, try eyebrow stencils—you'll get a perfect shape every time.

eyebrows

Fill 'em Up

If your eyebrow hairs are sparse—or if you've been too enthusiastic with the tweezers—you'll need to fill them in with an eyebrow pencil or powder.

1. Always go for a shade lighter than your hair.

2. With fine, short strokes, use the pencil or a firm, angled brush to sweep on a brow powder in the direction of hair growth.

3. For a natural finish, blend in the shade with a Q-tip, and seal with a clear brow gel.

Hit the Bleach

Lightening your brows can open up your face, giving you a radiant glow. And it's so easy to do at home!

1. Follow the package directions to mix the facial hair bleach.

2. Paint it thickly over your brows—for a warm chestnut, leave it on for one minute; for a strawberry blond, try five.

3. Wash off the bleach. Too light? Simply enhance with brow powder.

The Bush Twins

When your brows are super-thick, locating your arch can feel like a lesson in futility. Guess what? All you need is a white eye pencil and five minutes!

1. First, brush your brows upward to see what you're working with.

2. With a white pencil, trace a line just underneath your brow, where you want your arch to be (it helps to look at a photo of a celebrity with a similar brow shape). Then pencil in the area under the line. Pluck the hairs only within the white area.

3. Rinse off the white pencil with eye-makeup remover, and voilà: clean, perfectly arched brows.

 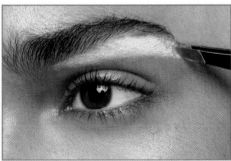

No Pain, No Gain

Plucking hurts. But you can considerably cut down on pain and redness with these helpful hints.

1. Before tweezing, rub Anbesol or an ice cube over your brows and the surrounding area. This will numb the skin.

2. Spread the area flat with the thumb and index finger of your opposite hand, then begin tweezing. You'll prevent plucking your skin along with the hair—ouch!

3. To soothe reddened, freshly plucked skin, swipe on an astringent-soaked cotton ball, or rest damp, steeped chamomile tea bags on the area.

eyeshadow

So there's that old saying that the eyes are the window to the soul.
If that's true, then it seems only right to flaunt them with a fabulous
window treatment: eyeshadow.

Eyeshadow is a powerful thing; done right, it can instantly transform you.

A touch of shimmer can give you a playful look, while a smokier shadow can
turn you into a vixen. A sheer wash will make you look soft and romantic.
What you choose depends on your mood, your outfit, a Magic 8-Ball.
It has zero to do with your skin color.

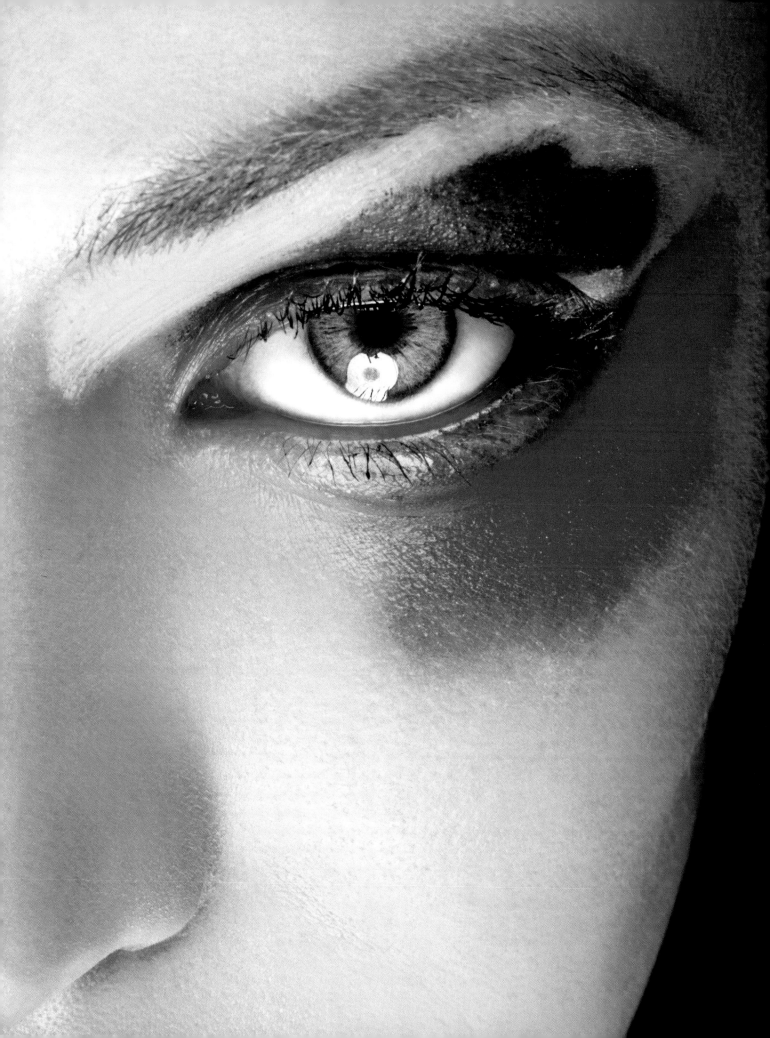

eyeshadow

Collect Them All!

Take your pick from these eyeshadow types:

1. Sheer: These are the most versatile shadows. A sheer might look opaque in the packaging, but when you swipe it on your skin, it's practically see-through. These soft, hint-of-a-tint hues are key if you want color without going all-out. For a subtle-but-sophisticated look, apply a pale sheer over lids and a deeper neutral in the crease.

2. Shimmer: Shimmers instantly sexify your eyes, giving you a playful, twinkly glow. Certain hues like champagne, gold, and pearl can instantly awaken tired eyes if swiped all over the lid and dotted around the tear duct. Unfortunately, shimmer isn't a great choice if you have crepey lids—it settles into creases in the skin, accentuating fine lines.

3. Cream: Silent-movie stars used to coat their lids with Vaseline to give them a glossy, overcome-with-passion glow. These days, cream shadows do the same trick. The best part? You can swipe them on with your finger—perfect for on-the-go girls. But no matter what anyone tells you, *midday creasing is unavoidable,* so tote an extra for touch-ups.

4. Opaque Matte: These dramatic, highly pigmented shadows are beautiful if you're going for strong, no-holds-barred color. Smudge an opaque charcoal or navy around your eye for a big night out, or apply a vivid turquoise just for fun. Tip: dust your lids with a translucent powder first, so the shadow won't stick to oily spots, creating smears.

When applying an ultra-smoky eye shadow or tons of shimmery or glittery shadow, do your eyes before the rest of your face. Otherwise, black shadow particles and mica flecks will sift down onto your makeup and be as impossible to remove as leather pants in 98-degree weather. Use a makeup remover–doused cotton ball to swipe off the particles that sifted down onto your cheeks—then work on your foundation, concealer, and all that jazz. I know makeup artists are always talking about dusting white powder under your eyes to catch the shadow and protect the rest of your makeup, but believe me, my way is easier.

Smoke Gets in Your Eyes

The tools:
Peachy-beige shadow
Iridescent black shadow
Matte black shadow
Black eye pencil
Black mascara

1.

2.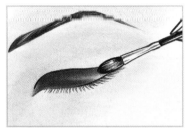

3.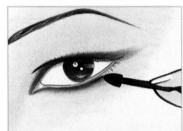

4.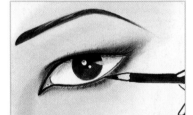

5.

The steps:

1. Peachy-beige shadow is applied to the browbone.

2. A layer of iridescent black shadow is softly blended from lash to crease.

3. Matte black shadow is blended all around the eye.

4. Top and bottom lashlines are rimmed with black eye pencil.

5. Lashes are defined with two coats of black mascara.

Tracy, Philippines

Retro Punk

The tools:
Matte peach shadow
Matte teal shadow
Matte green shadow
Individual lashes and eyelash glue
Black eye pencil
Black mascara

1.

2.

3.

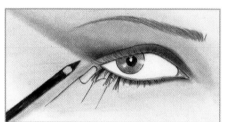

4.

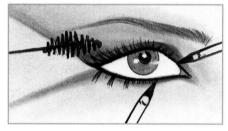

The steps:

1. Peach shadow is applied in a wide circle from the inner corner of the eye up to the inner corner of the eyebrow, around to the brow arch, and down to the lashline.

2. Teal shadow is applied from lash to crease. Then, using a long eye pencil as a stencil, the teal shade is extended in a wide band diagonally from the outer eye corner across the outer tip of the eyebrow, and out to the temple (becoming sheerer as it goes).

3. Green shadow is blended along the bottom lashes, and using a long eye pencil as a stencil, it's extended from the outer corner down toward the ear. Individual lashes are applied to the bottom lashline with invisible glue, and when dry, a coat of mascara is applied.

4. Black eye pencil is traced along the inner rim of the bottom lashline, then top and bottom lashes are coated with black mascara.

Bea, Brazil

Peacock Pretty
The tools:
Emerald shimmer shadow
Gold shimmer shadow
Violet shimmer shadow
Blue shimmer shadow
Black mascara

1.

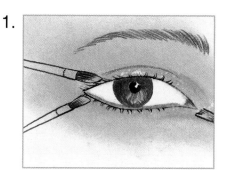

2.

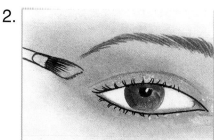

3.

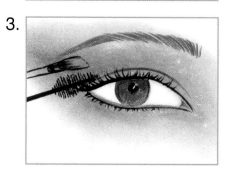

The steps:

1. Emerald shimmer shadow is blended all around the eye—from lash to crease, and along the lower lashline—and gold shimmer shadow is applied to the inner corner of the eye.

2. Violet shimmer shadow is blended onto the crease, applied to the outside corner in a V shape, and extended out to the temple.

3. Blue shimmer shadow is applied from top of crease to browbone, to crease, and along the lower lashline—and gold shadow is applied to the inner corner of the eye. Apply a generous amount of mascara.

Charity, USA

eyeliner

The hottest girl at the party is invariably the one with the glittery spaghetti strap sliding down her shoulder, who laughs with her head thrown back. You always envy her flippant sexiness and wonder what her secret is. A fourth "Apple-tini"? Chanel No. 5? La Perla undies? Hardly—it's just black liner!

A sexy smudge of kohl-black liner can make the difference between a "can we go now?" night and an "it's already *six in the morning*?" night.

Liquid, pencil, shadow liner—it's all good, and everyone, no matter eye shape or color, instantly looks better with a good swipe of the stuff. Indian women have the right idea—many line their daughters' eyes with kohl even when they're children! Love it.

Party Lines

Drawing a line inside the rim of your lower lashline adds instant sultriness to your look. To do this, gently pull down on the skin under your bottom lashes, and line the inside rim with a black eye pencil (never use liquid liner on the inside rim). If you have small eyes, however, this can make them look smaller, so you should use white eye pencil instead.

The tool:
Black Liquid Liner

The steps:

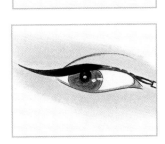

1. Look down and relax lids. Crinkled lids make for a crooked line.

2. Steady your hand by placing the inside of your wrist just above the side of your jaw. Create a slight winged arc at the outside corner of your eye.

3. With short, feathery strokes, extend the line to the inner corner. If you have deep-set or Asian eyes, keep them closed for a couple of seconds, until the liner is dry—this will prevent it from smudging on your upper lids.

Shadow Liner
For the softest look, try this:
1. Dip an angled eyeliner brush into a deep brown or black eyeshadow. Tap off excess powder.

2. Look down. Starting from the outer corner, trace a line along your upper lashes to the inner corner.

3. Don't worry if the line isn't perfectly straight—just use your index finger to blend.

Pencil
Want to look more polished? Follow these tips:
1. Start with a sharp, slightly warm eye pencil (if it's too hard, run it back and forth along your hand a couple of times). The warmer the pencil, the smoother the application.

2. Draw the line from the outer to inner corner, decreasing in thickness as you go. Keep it as close to the base of your lashes as possible—you never want skin to show between your lashes and liner.

3. Don't have a steady hand? Instead of drawing in a continuous line, create a series of dots along the lashline, then blend the line with a smudger.

eyelashes

Batting one's lashes is a lost art. What could be more fetching than lowering your eyes, looking up through thick, lush lashes, and "pseudo-innocently" batting a few times? Of course, long, full lashes make the difference between looking incredibly hot and looking like you're trying to blink lint out of your contacts. Roughly twelve of us were born with Diana-Ross-in-*Mahogany* lashes (actually, neither was she), so it's all about faking it.

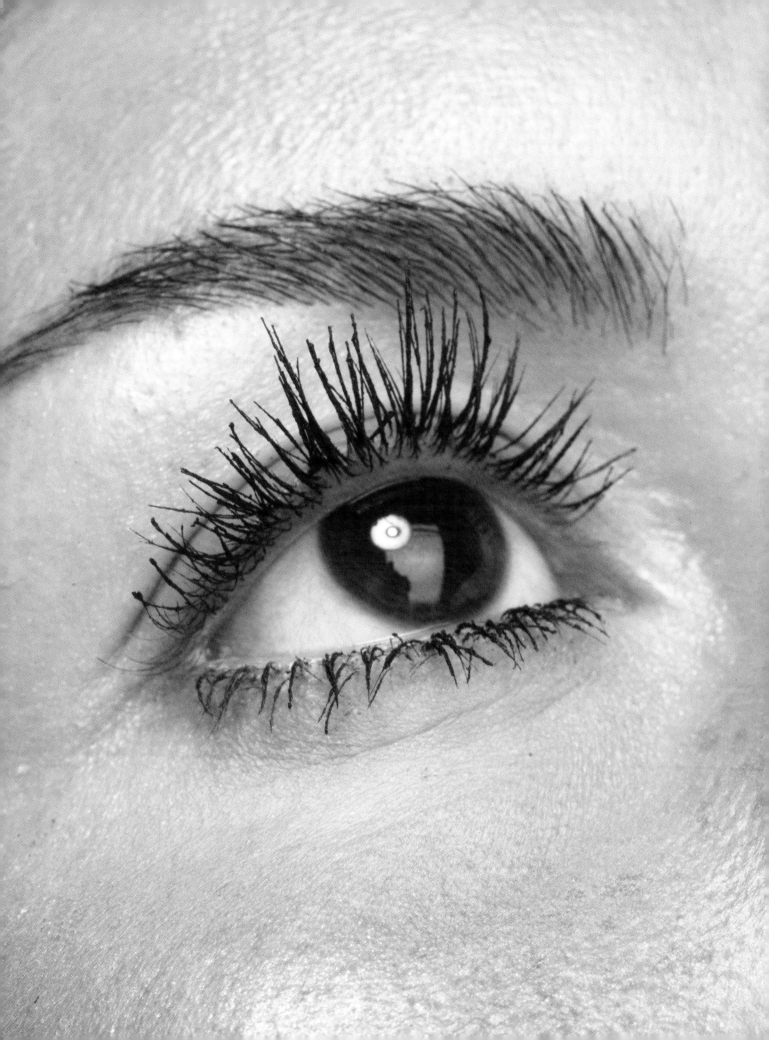

First step: The Eyelash Curler

First things first. Unless, like many black women, you have super-curly lashes, curling your lashes is absolutely essential. It lifts and fans them out, making your eyes appear bigger. Don't be frightened of the medieval-looking tool—here's what to do:

1. Start with clean, unmascara'ed lashes.

2. Look down, and place the curler at the base of your lashes.

3. Clamp down and hold for five seconds. If your lashes are coarse and super-straight, like many Middle Eastern and Asian women's, use a heated eyelash curler or lightly pump the curler from the base to the ends of your lashes.

4. Release, and move on to your other eye.

Second step: Primers

Acrylic primers! I can't talk about them without gushing. An acrylic primer is key to getting truly outstanding—dare I say epic—lashes. The gooey white formula is blended with tiny fibers that adhere to your lashes, clinging to the ends and extending slightly beyond. When mascara is layered on top, your lashes will appear twice as thick and long.

Some new mascaras come with acrylic fibers already blended into the formula. If you have one of these, disregard this step!

Third step: Mascara

Get the most out of your mascara with these tips:

1. To increase volume, jiggle the wand at the base of the lashes, and then sweep it upward to the ends. Repeat on bottom lashes.

2. Let dry for twenty seconds before applying a second coat (if you're in a hurry, skip this step). Letting lashes dry thoroughly between coats helps prevent clumps.

3. Okay, sometimes clumps are unavoidable. To get rid of them, run an eyelash comb through your lashes, or pinch clumps off with your fingers.

Expiration date

Get a new mascara at least every two months—you'll avoid bacteria buildup. And if it starts smelling funny before then, chuck it.

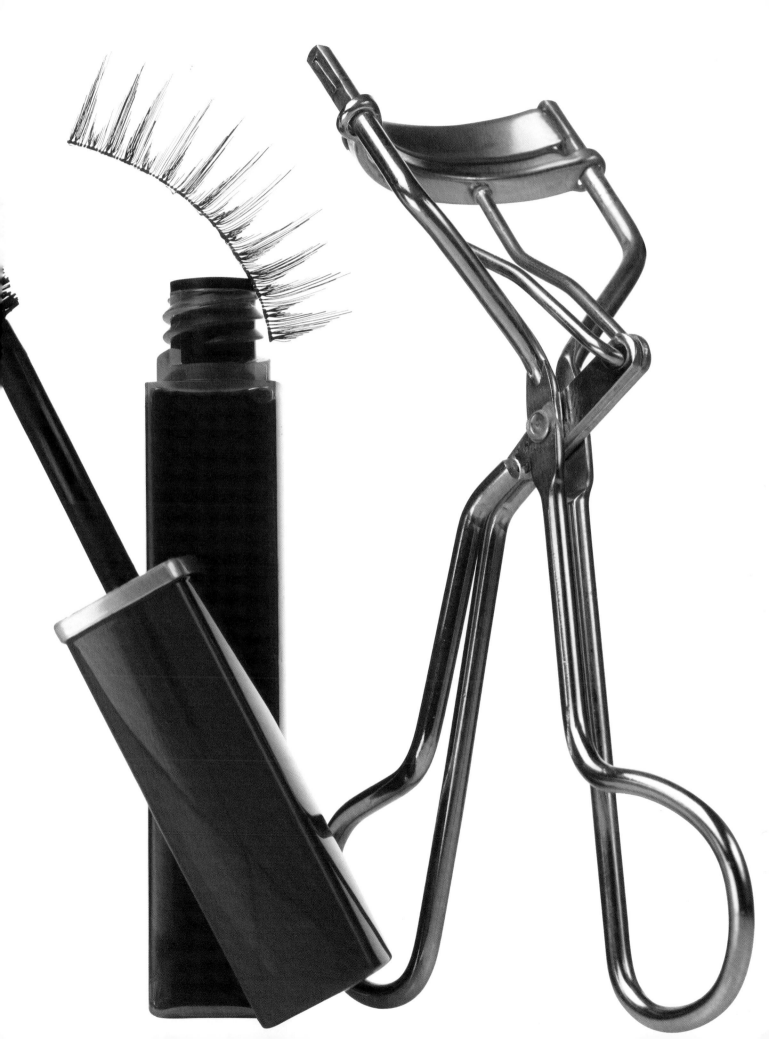

Batting a Thousand

The tools:
Eyelash curler
Tweezers
Row of false lashes
Eyelash glue
Individual lashes
Mascara

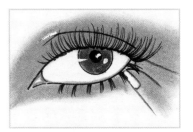

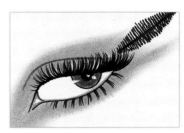

The steps:

1. Upper lashes are curled and mascara is applied.

2. With tweezers, the row of false lashes is dipped into glue and placed from outer to inner corner of eye.

3. Again with tweezers, individual lashes are dipped into glue and placed, evenly spaced, onto bottom lashline.

4. Lashes are curled to "marry" false ones to your own.

5. Apply a generous amount of mascara.

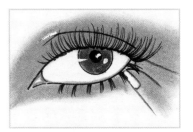

Iman, Scmalia

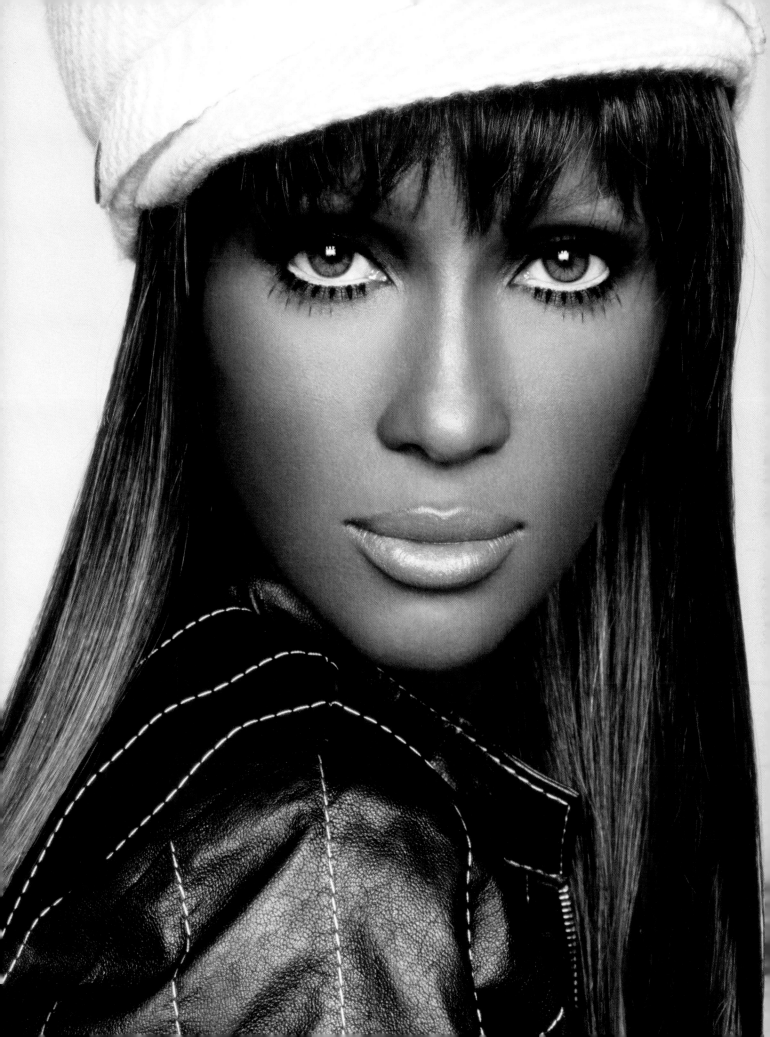

I bet you remember how your mother's lipstick smelled when, before she went out for a night on the town, she leaned in to kiss you goodnight. Am I right? And her lipstick was probably the first makeup you tried on, too. Oh, lipstick! Lipgloss, lip stain, all of it!

There's something so intrinsically fun and sensual about painting your lips.

What could possibly be troubling when you've got lips the precise shade of a ripe pomegranate?

And now, the two-toned-lip issue. For many women with skin of color, the lower lip is lighter than the upper lip. To even things out before applying lip color (especially light shades), line and fill in with a pencil the same shade as your darker lip.

Clara, Sudan

lips

Matte Lipstick

Opaque, rich, non-shiny shades last the longest of all the formulas. These can be beautiful if you're working a red-lips-and-nothing-else 50's look, or a nude lip with a smoky eye. Avoid matte lipstick if your lips are dry or chapped.

How to apply: First, line and fill in your lips with a pencil that matches the darker lip. Then, with a lip brush, apply the lipstick from the center of your lips out to the edges.

Sheer Moisturizing Lipstick

Definitely more casual (and forgiving) than their matte counterparts, these lipsticks contain moisturizing ingredients like vitamin E or jojoba oil to keep your lips supple and soft.

How to apply: Sheer shades don't need as much structure as mattes. Apply them from the tube without lip liner, or pat them on with your finger.

Lip Stain

When you look at a lip stain in its packaging, it usually seems super-dark and liquidy. But they go on rosy or berry-hued, and stay on a looong time. Stains are definitely not for commitment-phobes, but the look is lovely in a bee-stung, no-really-this-is-my-natural-lip-color way.

How to apply: Quickly.

Lipgloss

Glosses come in many different textures, from lacquer-thick and syrupy to light and slippery. In short, what's not to love? Two great reasons to use gloss: It makes thin lips look plumper, and the shiny finish is downright disco-hot. Very "Le freak, c'est chic."

How to apply: Sweep on with a wand, or if it's in a pot, dab on with your finger. Glosses aren't supposed to look perfect! But for a more pristine look, line and fill in lips with a matching lip pencil (the smartest brands have just come out with sheer pencils that complement the texture of gloss), then apply the gloss.

Now that you know all the beauty basics, it's time to divulge the number-one makeup secret that industry insiders have employed from time immemorial.

Every look is based on one of four eye/lip combos—light eye/light lip; light eye/dark lip; dark eye/light lip; dark eye/dark lip. It's about balancing your features and mixing and matching. Once you have these "beauty building blocks" down, not only will you be equipped to create any look under the sun, you'll also know which basic combo flatters your features most.

You heard it here first.

Look 1: Light Eye/Light Lip

It's all about looking *natural*—fresh, dewy, romantic, radiant. This is a sauntering-through-SoHo-wearing-a-Chloé-sundress look. No-makeup makeup.

TIPS: Use matte neutral shadows for an ultra-clean look and shimmery creams for a fresher, more dewy finish. On lips, stick with warm camels, coffees, and toasts—anything with a bit of a golden undertone works.

Look 2: Light Eye/Dark Lip

Almost bare eyes with deep lips are classic and elegant—very 1950's, very ladylike. And if you have a beautiful mouth, or feel like your smile is your best feature, this look might be a trademark waiting to happen!

TIPS: Skip shadow altogether and load on the black mascara—so pristine. Now go ahead, punch up your mouth with the deepest, most dramatic shade you can find—burnished plum, true crimson, deep bronze. Just make sure you blot and reapply, so that the color lasts all day. Or night.

Look 4: Dark Eye/Dark Lip

This look is not a game—we're talking deeply serious glamour. This is the girl with the mink stole (it's faux, don't want to ruffle any feathers, as it were) casually strewn across her shoulders, her Versace vixen gown clinging to every curve.

TIPS: Now's not the time to be timid, but to avoid looking clownish, make sure you pick eye and lip shades in the same tone. If you're working a shimmery bronze eye, try a golden-chestnut lipgloss. If it's a purple eye, the lip could be an eggplant stain.

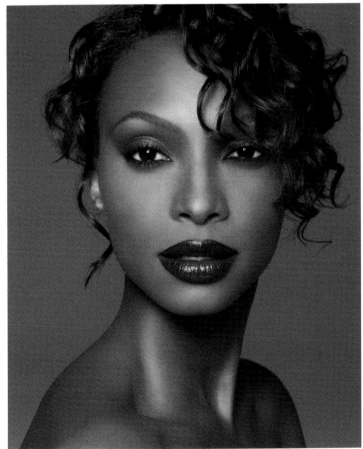

Look 3: Dark Eye/Light Lip

Equal parts designer highlights, 7 jeans, and Jimmy Choos, this is the quintessential sexy-party look. And since the spotlight is on your eyes, there's no lip maintenance during the night—so go ahead, kiss that boy till they turn the lights on.

TIPS: Contrary to popular belief, smoky doesn't mean only gray or black. Get colorful with purples, emeralds, even maroon—but keep lips subtle with a slick of gold gloss.

Jasmin, USA

3

RᴇMIX

Channel Your Inner Chameleon

So, now that you know the rules, forget them. The fun part is creating faces, playing with color. Why not switch up your makeup with your mood, your outfit, even the Dow Jones average? Whether you're going for an edgy, punk-chic style or a luscious, bronzed, island-mama look, remember to add your own special twist—make up your own rules!

"I like dress-up. I love hair and makeup. I love all that."
—Halle Berry, African-American, actress

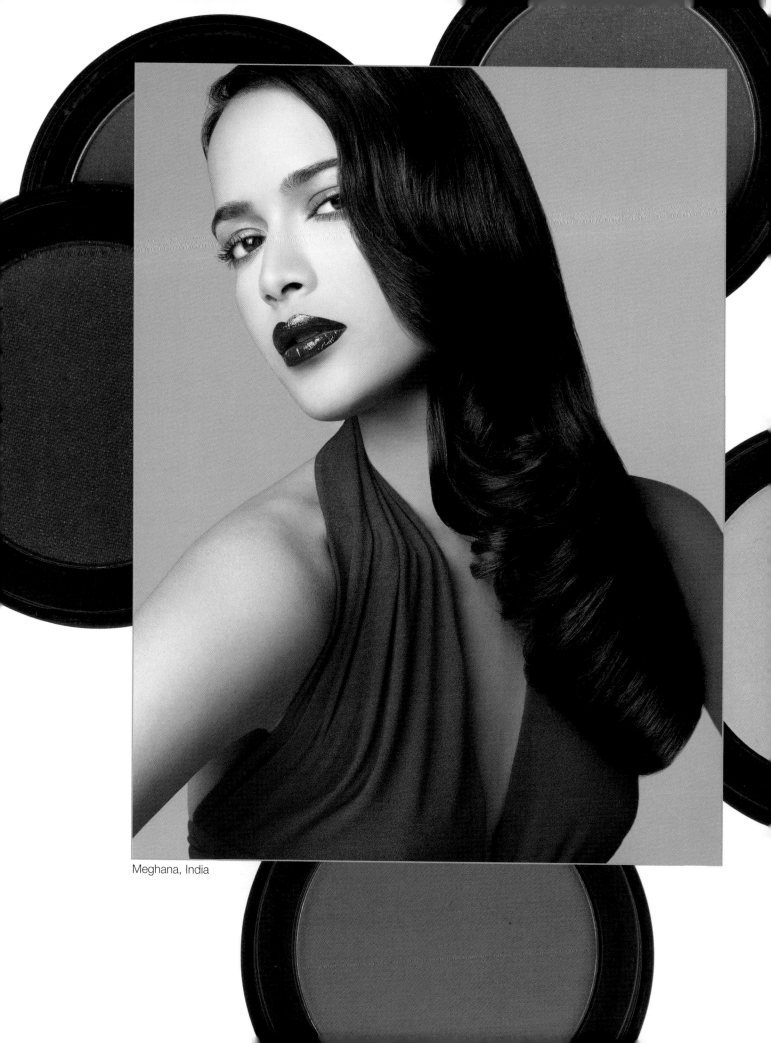

Meghana, India

S c r e e n Q u e e n

There are a zillion ways to make heads turn on a red carpet. For example, you could wear a see-through mesh dress, or a pink tutu, or a swan. But if we're talking about true glamour, the kind that amazes year in and year out, the "Old Hollywood Movie Star" always wins: hair falling in a soft cascade over one eye; flirty, battable lashes; lips red enough to make a bathtub full of rubies wail with envy. Rita Hayworth did it fifty years ago; Penelope Cruz does it today. Your turn!

The tools:
Sable shadow
Pearl shadow
False lashes and eyelash glue
Black mascara
Eyelash curler
Clear brow gel
Crimson-red lipstick
Lip brush
Red lipliner
Clear gloss

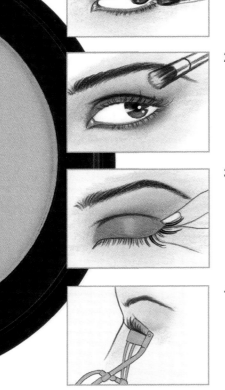

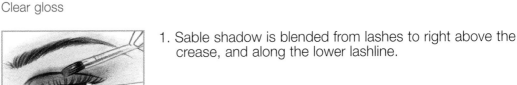

1. Sable shadow is blended from lashes to right above the crease, and along the lower lashline.

2. Pearl shadow is dusted on the browbone.

3. Lashes are applied to top lashlines.

4. After glue dries, top lashes are curled, and two coats of black mascara are applied to top and bottom lashes. Unruly brows are sleekened with a swipe of clear brow gel.

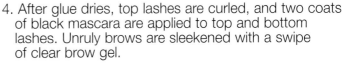

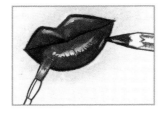

5. For a perfectly defined red mouth, lipstick is first applied straight from the tube. Then, with a lip brush, color is blended to the edges of the lip, from the center outward. Finally, lips are traced with a lip pencil. For extra shine, clear lip gloss is dabbed onto the center of the lips.

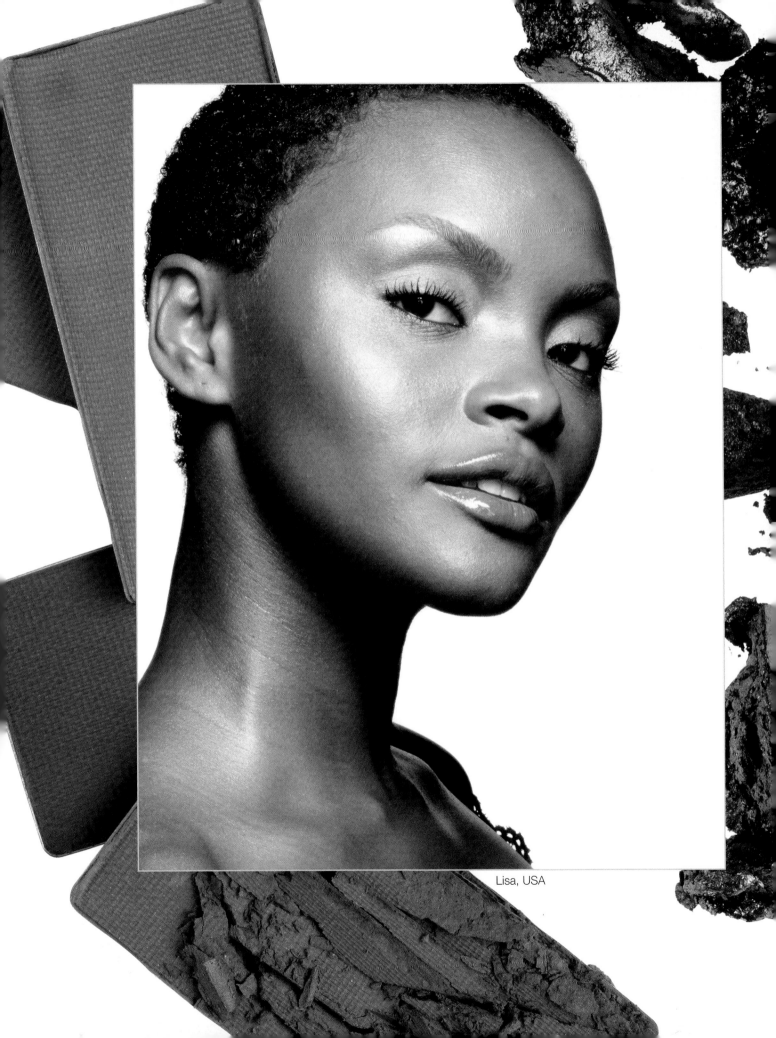

Lisa, USA

NudeScene

Ahh, the mystery of looking makeup-free, looking "natural." Men always say they like us best this way, but of course, the darlings are unaware of the almost Herculean effort involved in achieving "natural" nirvana. What exactly does natural mean, anyway? It really depends on where you live and if you're on the pageant circuit. All I know is this is what I think natural should look like: warm, creamy-golden skin; sunlit cheeks; softly radiant eyes; and glossy, nude lips.

The tools:
Facial hair bleach
Taupe shadow
Mocha shadow
Pearl shadow
Black eye pencil
Black mascara
Golden brow pencil
Cinnamon blush
Honey lipgloss

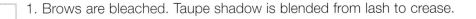

1. Brows are bleached. Taupe shadow is blended from lash to crease.

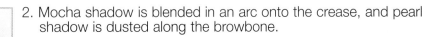

2. Mocha shadow is blended in an arc onto the crease, and pearl shadow is dusted along the browbone.

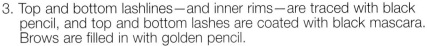

3. Top and bottom lashlines—and inner rims—are traced with black pencil, and top and bottom lashes are coated with black mascara. Brows are filled in with golden pencil.

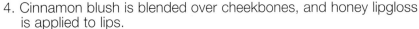

4. Cinnamon blush is blended over cheekbones, and honey lipgloss is applied to lips.

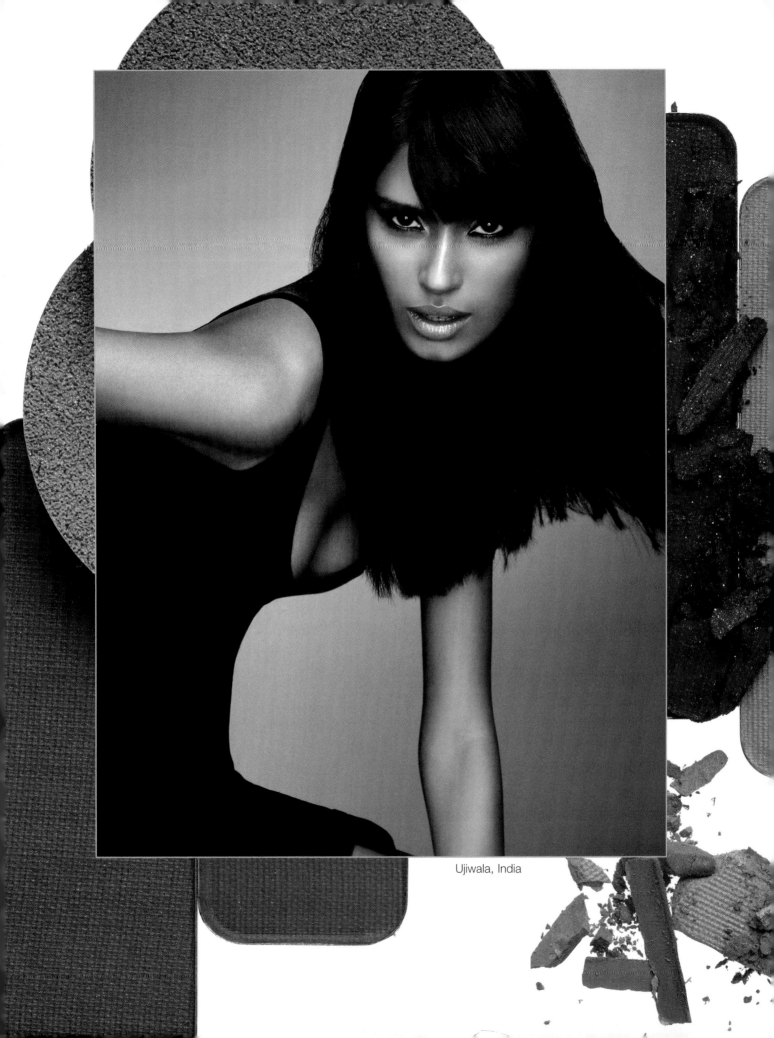

Ujiwala, India

The Vamp

You know the type. The other woman: cheekbones like cut glass; a curtain of mysterious, silky black bangs hanging over dangerously smoky eyes; cleavage that would smother your boyfriend and your dreams of a princess-cut diamond engagement ring. You immediately loathe her, but you're also dying to ask her what lipgloss she's wearing (it's that perfect "Don't you wanna kiss it off?" shade!). Feel free to steal her makeup secrets out from under her, right here. That man-eating *tramp*.

The tools:
Olive foundation
Yellow-based concealer
Black shadow
Champage shimmer shadow
Pearl cream shadow
Black eye pencil
Black mascara
Peach blush
Golden beige lipgloss

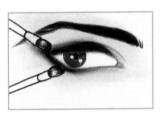

1. Foundation and concealer are applied. Black shadow is blended from lash to crease, along bottom lashline, and extended toward the temple at the outer corner of the eye.

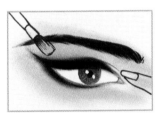

2. Champagne shadow is applied along the browbone. To add a shot of radiance, pearl cream shadow is blended in inner corners with fingers.

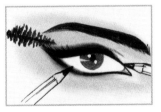

3. Black eye pencil is traced along top and bottom lashlines and inner rims, and lashes are coated with mascara.

4. Peach blush is swept up along cheekbones, and gloss is applied to lips.

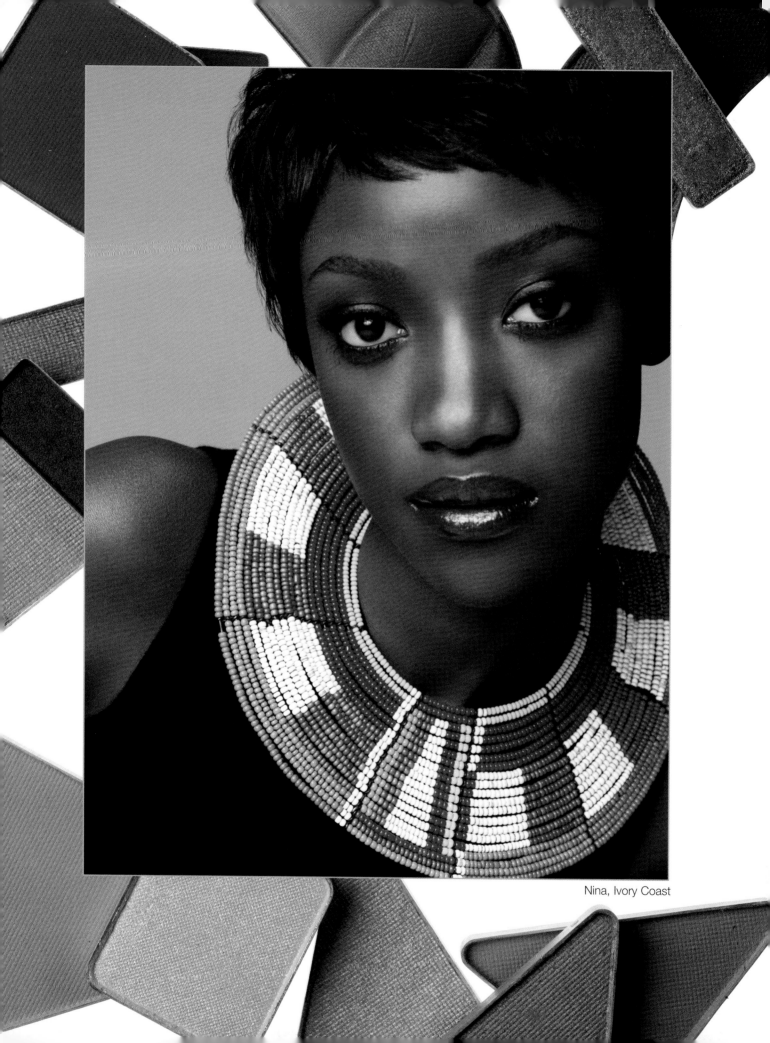

Nina, Ivory Coast

Masai Gamine

I love to look to the 1960's for inspiration—it was such an amazing time for makeup! Here, we're channeling the mod pixie look. Defined by gorgeous gamines like British model Twiggy and actress Jean Seberg, this was about huge, wide eyes with major-league lashes, nude lips, and cropped haircuts. But as great as mod was, you don't want to wear it from head to toe—too costume-party. Instead, cross it with personal touches to create a new look. Here, I added a beautiful beaded Masai choker. You like?

The tools:
Charcoal shadow
Black eye pencil
Smudge brush
Tweezers
Individual false lashes
Eyelash glue
Eyelash curler
Black mascara
Eyebrow brush
Dark brown brow powder
Brick red blush
Sheer bronze lipgloss

1. Charcoal shadow is blended from lash to crease, and underneath bottom lashes.

2. Top and bottom lids—and the inner rims—are lined with black pencil and gently blurred with a smudger.

3. For major mod eyes, tweezers are used to attach individual lashes to top and bottom lashlines.

4. After glue dries, top lashes are curled, and two coats of mascara are applied to top and bottom lashes. With an eyebrow brush, brows are filled in with dark brown powder. Blend carefully.

5. Blush is dotted and blended over the apples of the cheeks. Major eyes should always be balanced with a neutral, unfussy mouth. Skip lip liner and slick on a sheer bronze gloss.

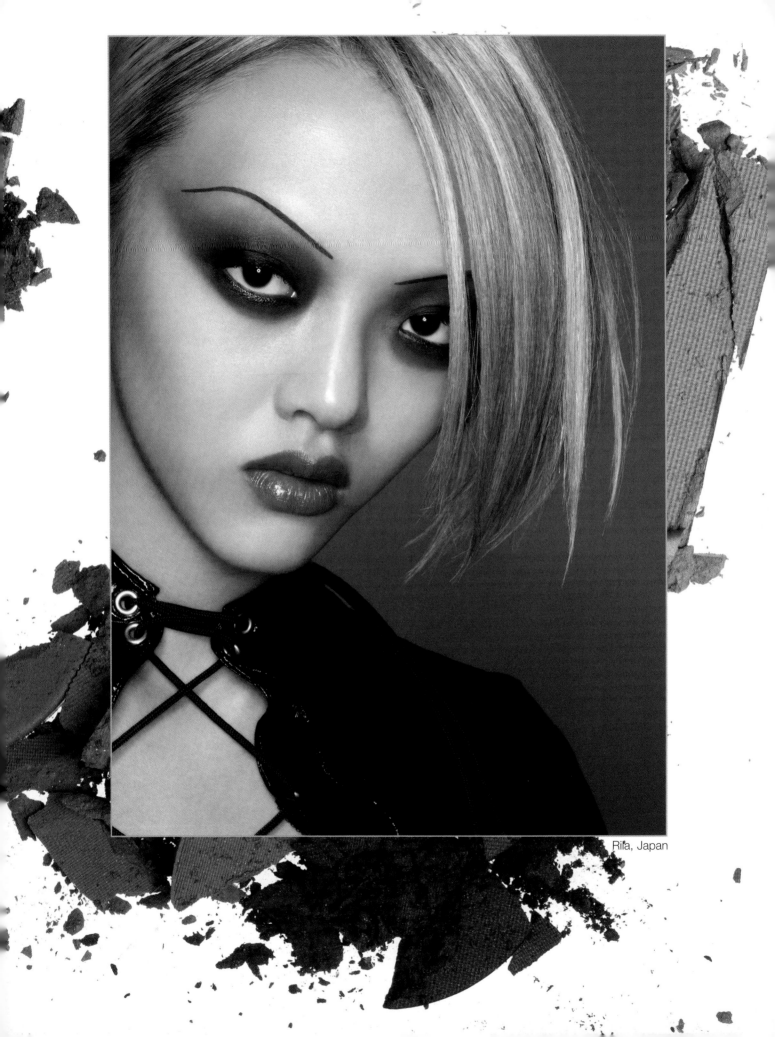

Rifa, Japan

DominatrixDiva

Who wouldn't want to be this girl for a day? I'm sure her man kneels at her feet, shouts "hup-two-three-four!" at the sound of her voice, and answers "yes, ma'am!" at the command to hold her "maybe" pile at the Marc Jacobs sample sale. Perhaps this little leather-whips-and-markdown fantasy won't come true, but you can at least be a poseur in sexy, hardcore, my-way-or-the-highway makeup, right? Yes ma'am.

The tools:
Black shadow
Gray shadow
Coral shadow
Cream shadow
Black eye pencil
Black brow pencil
Black mascara
Lip brush
Coral lipgloss

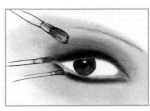

1. Black shadow is applied all around the eye in a circular shape from lash to crease, and along top and bottom lashlines.

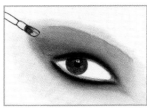

2. Gray shadow is blended from crease to just under browbone, and all around the eye, extending outward at outer corners.

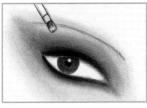

3. Coral shadow is carefully, lightly blended around the perimeter of the gray shadow, and swept out at the corners toward the outer end of the eyebrow. Cream shadow is swept along the browbone.

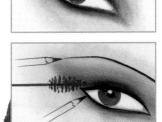

4. Black eye pencil is traced along top and bottom lashlines, and brows are accentuated with a fine-tipped black pencil. Mascara is applied.

5. Coral gloss is painted on.

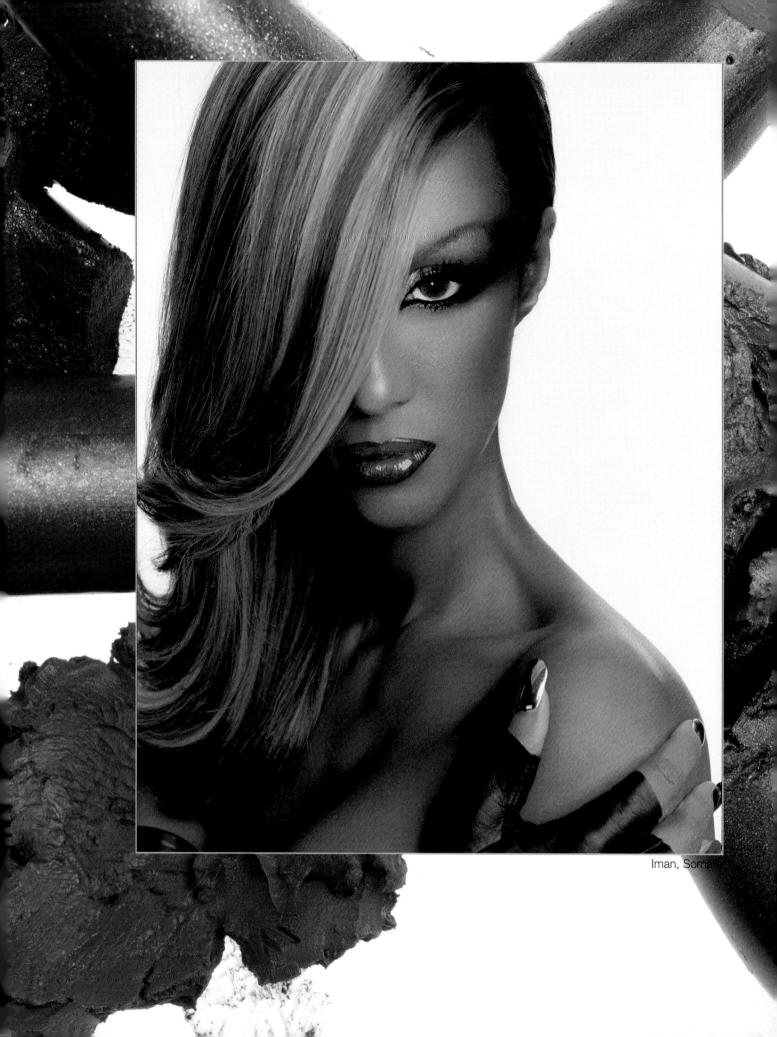

Iman, Somalia

Ghetto Fab

We all know this girl. She's dripping in security guard–worthy carats of bling while wearing Lee press-on nails. Both her eye color and her eyelashes are fake, but she's the realest girl in the room. She wears fuchsia lipgloss to brunch. She loves gold glitter and Gucci. She's unapologetically high-maintenance, her tongue's always in cheek, and you wish you had *half* her moxie. Not to worry—what you don't have, you can fake. She always does! Shed your inhibitions and channel your inner Mary J. Blige, Lil' Kim, or Christina Aguilera with this flashy, fly, ghetto-fabulous face.

The tools:
Gold shadow
Smudge brush
Red matte shadow
Black eye pencil
Green iridescent shadow
False lashes
Invisible lash glue
Black mascara
Eyelash curler
Wine-hued lipstick
Matching lipgloss

1. Gold shadow is blended over the entire lid, from lashes to brow.

2. With the smudge brush, red shadow is blended onto the crease up to the bridge of the nose.

3. Top and bottom lashlines are rimmed with black pencil.

4. Green shadow is faded under the eye and out toward the temples.

5. False lashes are applied to top lashlines with invisible glue.

6. The glue is allowed to dry for two minutes, then one coat of mascara is applied to marry real lashes to the fake ones.

7. After the first coat of mascara is dry, lashes are curled at the lashline, and two more coats are applied. Finish with a deep wine lipstick and a layer of matching gloss.

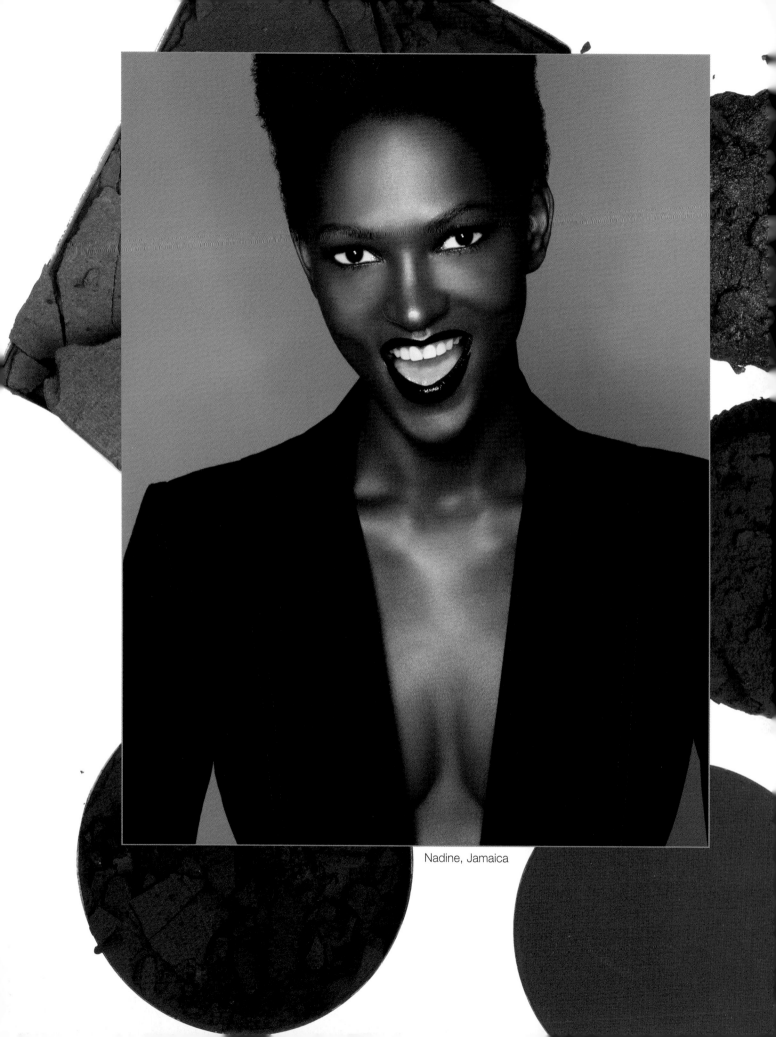

Nadine, Jamaica

N e w W a v e N o i r

Glamming out is so much fun, but it's not the only way to look sexy.
Don't get me wrong—I love big hair, big lashes, big earrings and all the
other hyperfeminine trappings as much as the next girl. But when you strip
away all that drama, and go for gorgeous skin, lips the color of the deepest
eggplant, and hair like an 80's New Waver, you get a look that's equal parts
breathtakingly beautiful and tomboy tough—a potent combination.
Just ask Grace Jones.

The tools:
Matte camel shadow
Black eye pencil
Smudge brush
Black mascara
Dark brown eyebrow powder
Eyebrow brush
Deep eggplant lipliner
Matching lipgloss
Lip brush

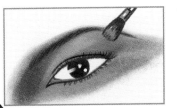

1. Matte camel shadow is swept from lashline to brow.

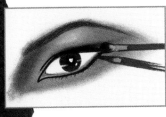

2. A thin line is traced along upper and lower lashlines
 with black eye pencil. With a smudge brush, the upper line
 is blended out slightly beyond the outer corners of the eye.
 Mascara is applied.

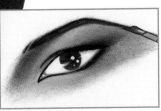

3. Eyebrows are filled in using dark brown brow powder
 and an eyebrow brush.

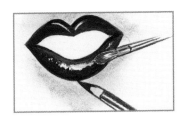

4. Lips are lined with eggplant lipliner and blended inward.
 With a lip brush, lipgloss is applied from the center of lip
 to the outer edges.

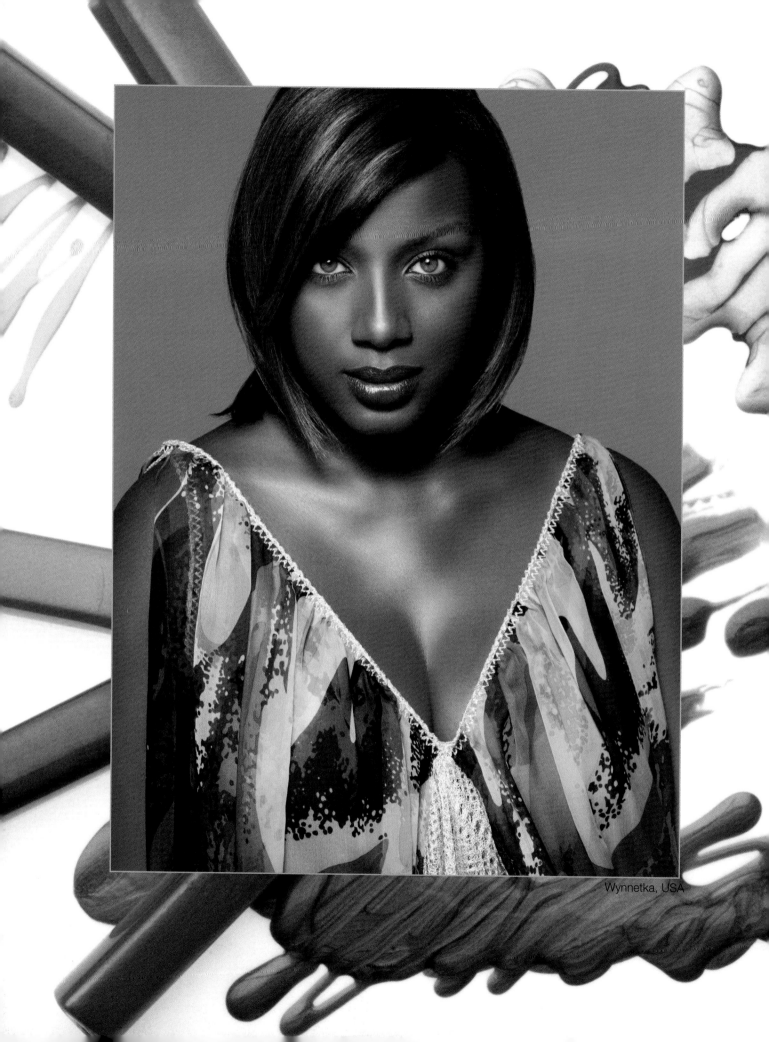

Wynnetka, USA

So Fresh So Clean

I hope you're taking notes, girls, because this soft, sexy (but *subtly* sexy, not I'm-a-Pussycat-Doll sexy—an important distinction) makeup is so flattering and so versatile that whether you're off to a huge meeting, a wedding, a blind date, or a party where you're unsure of the dress code, you'll somehow look exactly perfect for the occasion. Everyone needs a go-to look that they *know* makes them feel hot, no matter the occasion, like a little black dress or a particularly good-looking man. The best part? The face takes less than five minutes to create! Try it and see.

The tools:
Sheer gray shadow
Apricot shadow
Black eye pencil
Eyelash curler
Black mascara
Sheer magenta blush
Nude lip pencil
Merlot lipstick

1. Sheer gray shadow is applied from lash to crease, smudged along lower lashline, and winged outward at the outer corner of the eye.

2. Apricot shadow is blended just underneath the browbone.

3. Top lashlines are traced with black eye pencil.

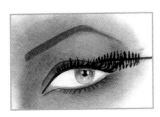

4. Lashes are curled, then both upper and lower lashes are coated with black mascara.

5. Sheer magenta blush is swept along cheekbones, and lips are lined with nude pencil and filled in with a merlot lipstick.

93

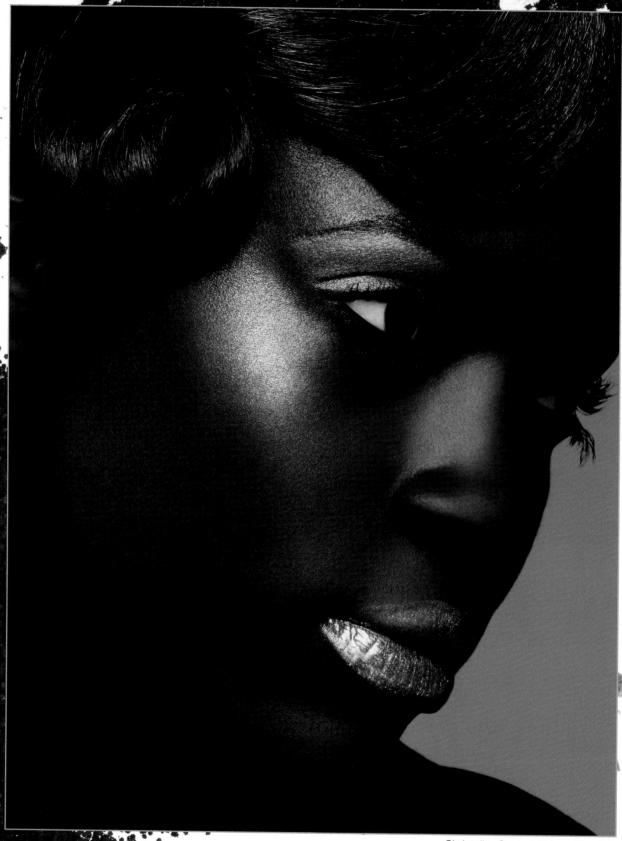

Christelle, Central African Republic

J u i c y Fruit

Rules are such a bore. Which is precisely why we all go to the men's room if the line to the ladies' is too monstrous. The archaic rules about who can really wear what makeup drive me crazy—like the one saying dark-skinned women can wear only deep plums and rich brown neutrals. Please! Fruit-punch pinks, lemon yellows, sheer tangerines—these tropical, citrusy shades look fantastic on all women of color (especially in the summer), because they wake up warm, golden undertones. So luscious!

The tools:
Matte yellow shadow
Matte berry shadow
Black mascara
Row of false lashes
Eyelash glue
Yellow mascara
Sheer hot-pink blush
Nude lip pencil
Sheer tangerine lipstick

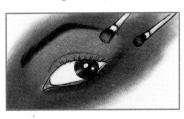

1. Yellow shadow is blended from lash to brow. Berry shadow is applied along bottom lashline, extending outward at outer corner of eye.

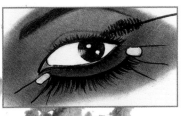

2. Top and bottom lashes are coated with black mascara. A row of false eyelashes is secured to bottom lashline.

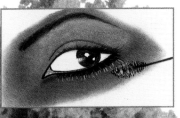

3. Yellow mascara is applied to tips of bottom lashes.

4. Hot-pink blush is swirled onto the apples of the cheeks, and extended upward along cheekbones. Lips are traced with a nude lip pencil, and filled in with tangerine lipstick.

Brenda and Mariana, Brazil

BadGirlGlam

No matter what's happening in fashion—whether it's a hippie-chic revival or a ladylike, Chanel-suit moment—slightly seedy kohl-rimmed eyes and lips drenched in redder-than-red gloss are *always* hot. Ask your man. Or just flip through your mental list of iconic bad girls—Apollonia steaming it up in a lace bustier, smoky eyes, and little else in *Purple Rain*. Lucy Liu kicking ass in black leather, major gloss, and don't-mess-with-me hair in *Charlie's Angels*. Yep, the bad girl always comes out on top. So to speak.

The tools:
Black shimmer shadow
Black cream shadow
Black volumizing mascara
Fuchsia powder blush
Red lipstick and red gloss

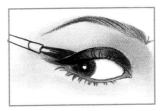

1. Black shimmer shadow is applied from lashes to crease, and winged outward at corner of eye.

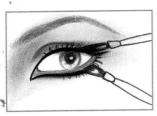

2. Black cream shadow is smudged along top and bottom lashes. Don't worry if it's uneven—the eyes aren't supposed to look too "done."

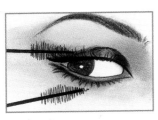

3. Two coats of mascara are applied to top and bottom lashes.

4. Fuchsia blush is swept onto the apples of the cheeks. Lipstick is applied from the tube, followed by a layer of red lipgloss on top, for extra shine.

4 CELEBSIGHTINGS
Indulge in Some Stargazing

It's all about the element of fantasy, of aspiring to be as beautiful, witty, and expertly turned out as your favorite star. But what I love is that *we* are the stars now. Hollywood looks a zillion times different from how it did twenty years ago! The next generation of young Asian, Latina, or black girls won't wonder if they're beautiful for lack of positive images of themselves in the media. They'll need to look no further than these bold, brazen, beautiful faces.

"Everyone always said, 'Oh, that face!'"
—Lena Horne, African-American, actress and singer

I m a n

Growing up in Somalia, I was mercilessly teased about my long, thin neck
(at six, I even started wearing my shirt collars up like James Dean). I didn't get
over it until I began modeling and met the high priestess of twentieth-century style,
Diana Vreeland. She put her bony hand under my chin and announced, "Now, *that's*
a neck!" Soon the whole fashion industry was echoing the same sentiment. I finally
figured it out—it's our imperfections that make us beautiful and unique.
My favorite part of the photo at left is the feather headpiece. My hairstylist created
it on the spot, by gluing feathers onto a wig cap—while I was wearing it! This pose
reminds me of the iconic Irving Penn photos of his wife, 50's model Lisa Fonssagrives:
swanlike, graceful, timeless.

"In a pinch, I can get very creative with a cream stick blush—I use it as blush, on my eyelids, and on my lips as a stain. There's always one in my bag!"

Get the Look
Create an ultra-smoky eye with black shadow,
and blend a shimmery peach shade at the
browbone. Apply false lashes and tons of black
mascara; then brush on shimmery crimson
blush and a slick of maroon lipgloss.

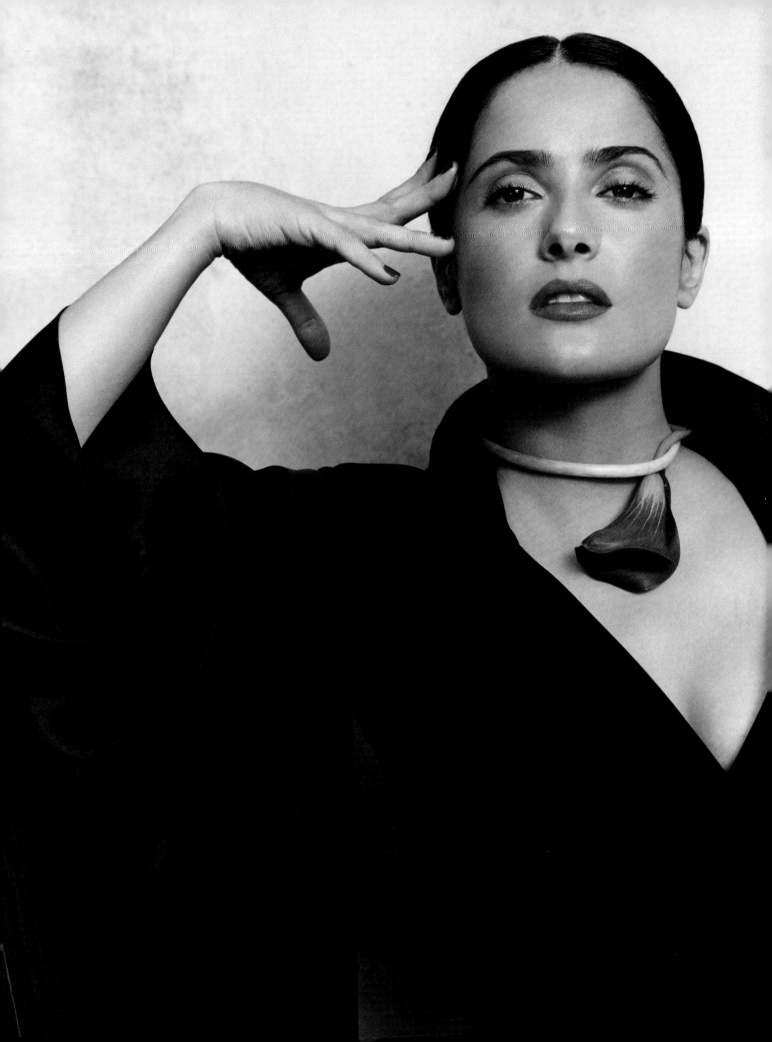

Salma Hayek

I'm in awe of Salma Hayek. And it's not about looks—you know, her Jessica Rabbit "I'm not bad I'm just drawn this way" figure, or her wild, untamably wavy ebony hair. No, it's for her bravery. Salma, who's of Mexican and Lebanese heritage, was brave enough to abandon a superstar career in Mexican soap operas for an uncertain future in Hollywood, all while hardly speaking English. She fought relentlessly for eight years to get *Frida* made—and finally produced, starred in, and received an Oscar nomination for the film! Now, *that's* moxie.

"A makeup artist once taught me a valuable lesson—never to mask my natural glow with heavy foundation. If you have to wear it, make sure it's *light*!"

Get the Look
Apply a nude shadow all over lid, and trace black eye pencil along upper lashline, and white eye pencil on the inside rim of the lower lashline. Curl lashes and apply mascara. Blend a sheer berry blush onto cheeks, line lips with nude pencil, and apply fiery crimson lipstick.

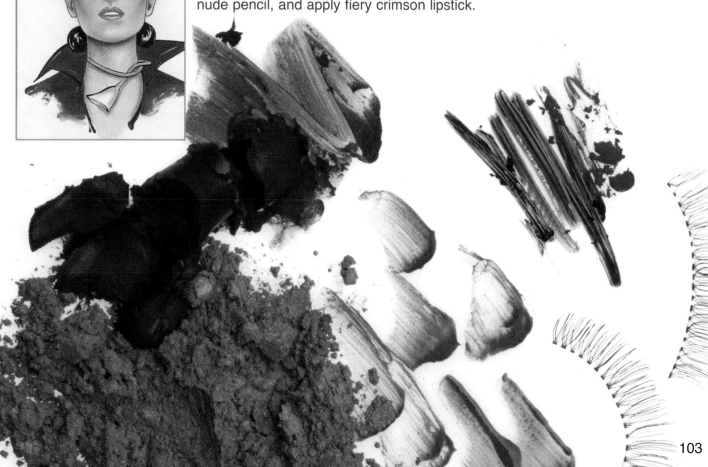

Venus and Serena Williams

Back in the day ("the day" being about ten years ago), Olympic gold– and Wimbledon-winning tennis champs did not at all resemble the Williams sisters. They weren't African-American. They did not saunter onto the court in color-coordinated visors, wristbands, and earrings. Nor did they become fashion designers in the off-season. Serena and Venus are stylemakers, and there's no one like them. I was dying to see them as golden goddesses —in shimmering, glimmering, warm metallics. How sexy!

Venus: "I'm obsessed with toner. As an athlete, you're active and perspiring a lot, so you have to be conscious of keeping your pores clean."

Serena: "I've always admired women like Cher or Diana Ross—they create trends and follow their own style, no matter what other people think."

Get the Look
To get Venus's russet radiance, blend a gold-flecked mahogany shade from lash to crease, winging out at the corner of the eye. Dust on a maroon blush, and apply a plum gloss. For Serena's golden glow, apply a deep bronze cream shadow, golden-orange blush, and a slick of golden gloss.

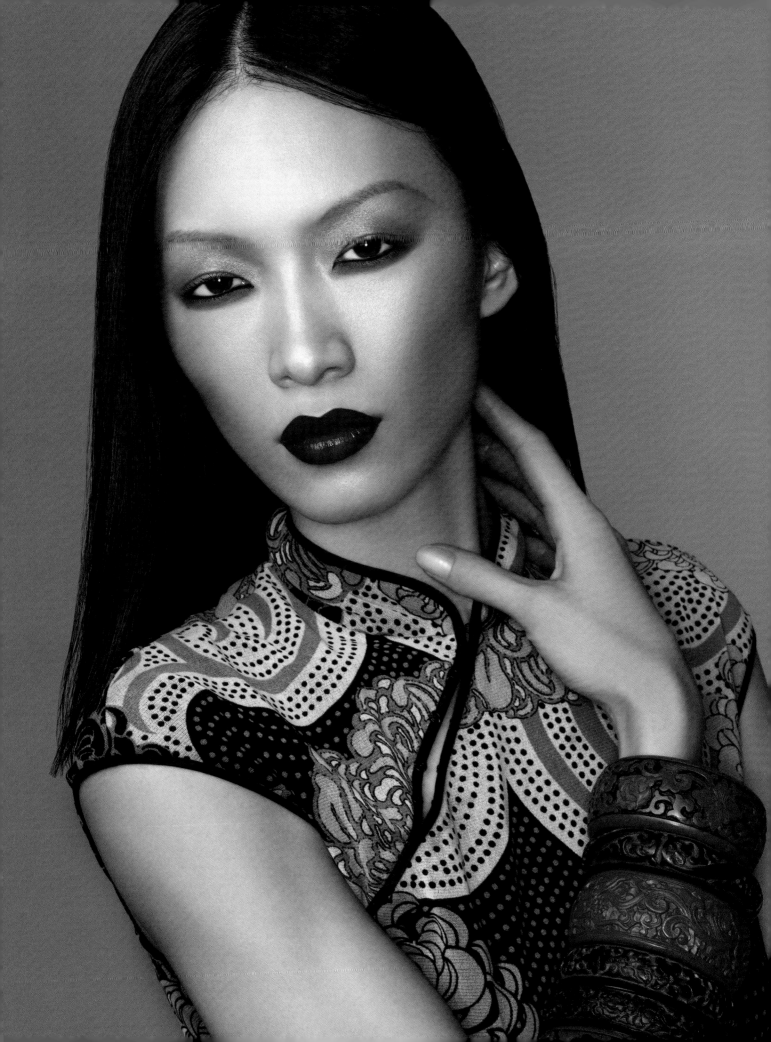

L i n g

Malaysian-born Ling is a supermodel—the real thing. She's been photographed by the likes of Stephen Meisel and Patrick Demarchelier. When she signed on with Prescriptives, she became the first Asian model to have a cosmetics deal worldwide. She's so hot she even starred on *Sex and the City* as *herself*. Yet, when I asked Ling to be in my book, she was so overjoyed that she made me blush! Underneath all the almost-intimidating glamour, she's a truly down-to-earth sweetheart.

"A great trick: At the end of a long flight, I'll have two cups of chamomile tea, then wring out the water and put the bags on my eyes. When I arrive wherever I'm going, I look fresh!"

Get the Look
Dust translucent shimmer powder over forehead, bridge of nose, and chin. Next, apply a copper-rose shadow from lashline to just under browbone, in an arch, and blend a thick line of lilac shadow along lower lashline. Rim lower lid with black eye pencil, apply black mascara and fill in brows. Dust on a sheer cherry-red powder blush, and apply a brick-red lipgloss.

Naomi Campbell

I met Naomi when she first started modeling, and instantly fell in love with her girlish charm. Okay, that and her killer body. She's always reminded me a bit of Josephine Baker—she has that same kind of wild, totally self-possessed beauty. Here I had the Jamaican-British icon interpret a photograph of Josephine during her 1920's "La Revue Negre" days in Paris, all shimmering limbs and catlike gaze. Thanks, Naomi, for totally getting the vision (and for letting me shoot you without your signature long hair).

"I'm a Gemini—so was Josephine Baker! We're colorful characters, changeable. I think people can relate to the different looks I'm capable of portraying."

Get the Look
Dust gold shimmer powder over forehead, cheekbones, bridge of nose, and chin. Then blend apricot shadow all over the lid, and black shadow all around the eye, extending past the outer corners toward the temple. Line top and bottom lashlines with black pencil, and apply black mascara. Blend on russet blush, and apply plummy bronze lipgloss.

Michelle Rodriguez

One minute, actress Michelle Rodriguez is the spicy-tongued tough-girl next door. The next, she's the glamour-girl prototype, a red-carpet vision tossing those waist-length waves and working some to-die-for designer confection. Well, there's no law saying she can't be both! At left, Michelle, who's of Puerto Rican and Dominican descent, channels the masculine and feminine—and I'll be damned if I can tell which is hotter.

"I couldn't be stranded on an island without tweezers, razors, or scissors. I wouldn't want to be hairy for the island boy."

Get the Look
Get tough with a smudge of brown around your eyes, penciled-in brows, and nude lipstick. To achieve a classic sex-goddess look, rim eyes in shimmery gray shadow, winging out toward temples. Brush on a sheer cherry blush, and finish with crimson lipgloss.

E v e

Who's that girl? Everybody knows . . . she's the platinum-selling MC; designer of her own clothing line, Fetish; and actress in blockbuster movies like *Barbershop*. It's E-V-E, arguably the first female rapper to bring vulnerable femininity, blazing sex appeal, and style (real style, tippy-top-of-the-designer-food-chain-clamoring-to-dress-her style) to the hip-hop game. She's a true diva. She deserves to be bronzed—and here, she is.

"A makeup artist once told me to apply Preparation H to undereye bags—strange, but it works every time!"

Get the Look
Blend metallic bronze shadow from lash to just under the browbone, and line top and bottom lashlines with black eye pencil, winging the line at the outer corners. Apply black mascara, attach a row of false lashes to upper lashline, then apply two more coats of mascara. Lightly blend matte crimson blush over cheekbones, and slick on tangerine-red lipgloss.

Rosario Dawson

This street-sexy actress is of Puerto Rican-Cuban-Irish-Native-American-and-black heritage (wow), but here she's a Parisian glamour girl. Picture this: Rosario and Bardot, her French poodle, are slinking along the Seine. She's wearing a jaunty beret and a cleavage-baring bustier, and is *shamelessly* dripping in diamonds. Smiling a mysterious smile, she leaves a trail of mesmerized men in her wake, all of them wondering how to get into her fishnets. This girl is pure fantasy (who wears a bustier to walk the dog?), but the dusky, softly muted makeup isn't.

"My grandmother is my beauty icon. I have an old photo of her looking in the mirror with painted-in brows and pulled back, dark curly hair. It's like a black—and—white portrait of Maria Callas—striking!"

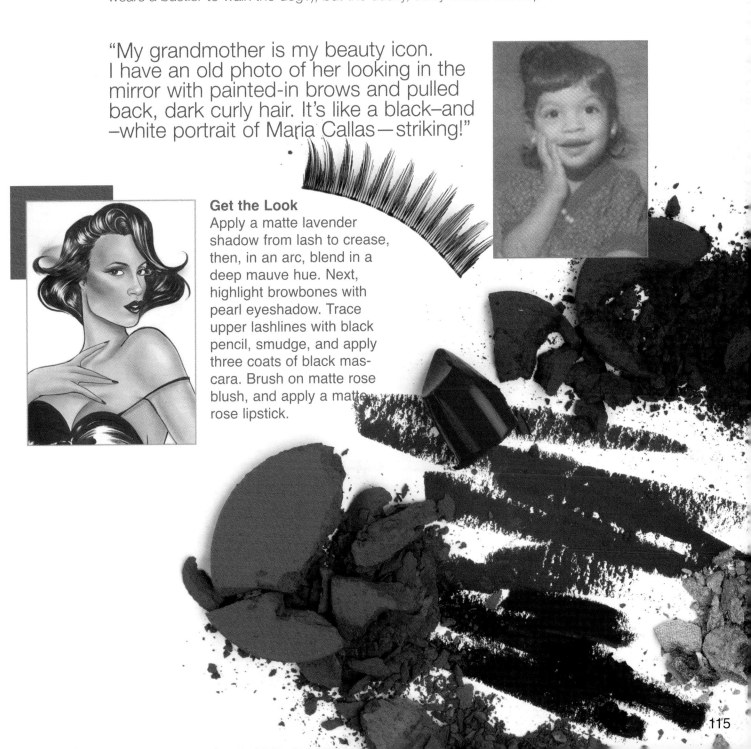

Get the Look
Apply a matte lavender shadow from lash to crease, then, in an arc, blend in a deep mauve hue. Next, highlight browbones with pearl eyeshadow. Trace upper lashlines with black pencil, smudge, and apply three coats of black mascara. Brush on matte rose blush, and apply a matte rose lipstick.

Vanessa Williams

What can you say about a woman who was the first African-American Miss America, and then went on to become a multiplatinum recording artist, Broadway musical star, and an NAACP award–winning actress? I think the term is "triple threat," no? Vanessa's always gorgeous, a super-glam, bronzed goddess, but I was itching to portray her as she's never been shown before—as a cool, kittenish beauty.

> "Blend, blend, blend, be it foundation, eye color, blush, etc., and it's all about the proper brushes and great products."

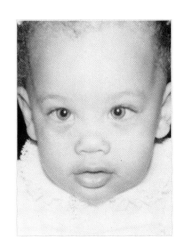

Get the Look

Dot and blend on an illuminating sheer foundation. Apply a sheer champagne shadow from lashes to just above crease, and a pearl shade along browbone. With a black pencil, line upper lashline, and with a white pencil, line inside rim of lower lashline. Blend a rosy blush stain onto the apples of the cheeks, and slick on a clear lipgloss.

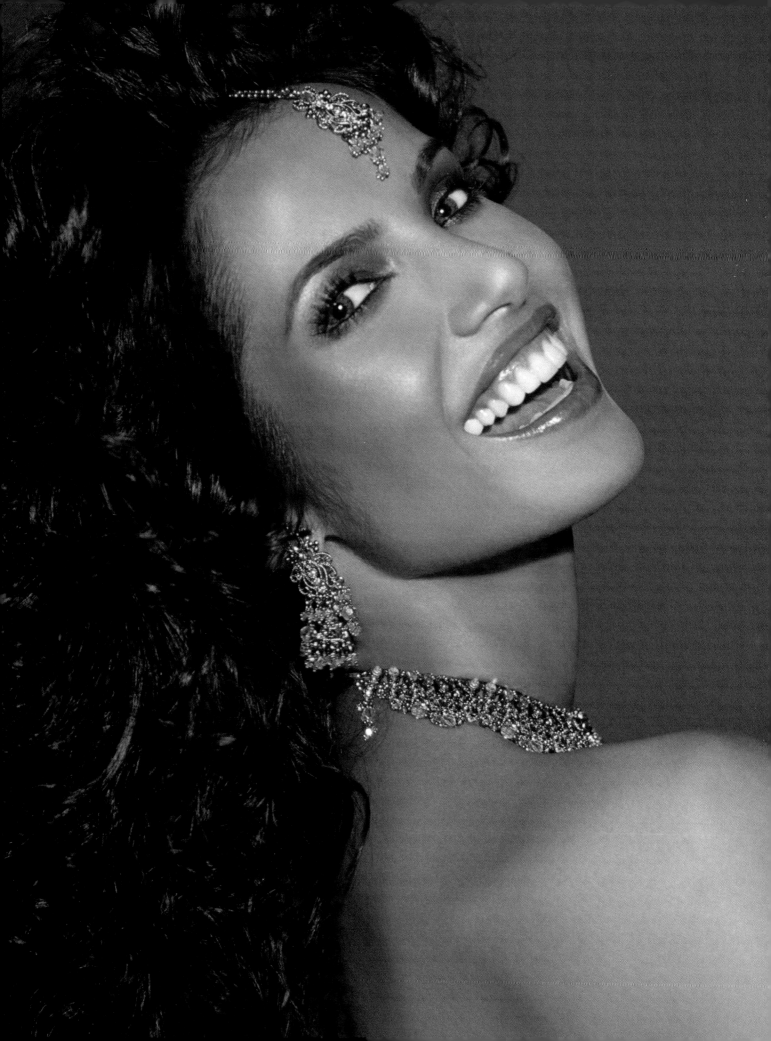

Padma Lakshmi

Padma's route to stardom is almost as remarkable as her beauty. Born in southern India, she grew up in the States and became a model while studying abroad in Spain during college. And now, after years of stalking catwalks for the likes of Versace and Armani, she's hosting her own cooking show, *Padma's Passport*, on the Food Network (it's not smoke and mirrors—she can cook like nobody's business). Here, she's a Bollywood princess, the star of a fantasy spectacular filled with a riot of lush colors and magical musical numbers. The choreography I can't help you with, but the makeup is easy.

"I used to love a beautiful Indian actress named Sharmila Tagore. I would copy her eye makeup and wing out my eyeliner like her—I still remember her every time I do my makeup."

Get the Look
Dust a deep lilac shadow from lash to just above crease, blend a pale lavender along the browbone, and apply a rose shadow along bottom lashline, extending past outer corner of the eye. Rim entire eye with violet-blue pencil, glue false lashes to top lashline, and apply mascara. Blend a berry cream blush along cheekbones, and apply sheer pink lipgloss.

E v a M e n d e s

Cuban-American actress Eva Mendes isn't sexy in a look-at-my-micro-mini-and-teacup-Chihuahua way. No, she's old-school—with her long, tawny limbs, her impeccably messy, just-rolled-in-the-hay hair, and her sultry, heavy-lidded dark eyes, she recalls the iconic sex goddesses from the 50's and 60's. Just watch *Training Day*—she looks exactly like the young Raquel Welch (who, by the way—because of Hollywood prejudices in the 60's—couldn't tell a soul she was half Bolivian)!

"I hope people understand that women with skin of color have many different looks, and they're all beautiful in their own right."

Get the Look

Set foundation with translucent powder for a matte finish. Thickly trace upper lashlines with black liquid liner, apply a row of false lashes, and coat with mascara. Outline lips with nude lip pencil, and fill in with brick-red lipstick.

Liya Kebede

The first time I saw this devastatingly elegant Ethiopian woman, I said to myself, "Here is the next black model to usher us into the future." I was frighteningly on-target, if I do say so myself—in 2004, Liya was the first black model to sign a contract with cosmetic giant Estée Lauder. And who better deserving? She's so divine that French *Vogue* once devoted an entire issue to her. Here, her skin is showcased with muted, earthy tones.

"I love this look! I'm a fan of film; it was great to be made to look like the glamorous classic Hollywood actresses."

Get the Look
Apply metallic chocolate shadow all around the eye—from lash to crease, and along lower lashline. From crease to just under browbone, blend on a paler, shimmery coffee shade. Line top and bottom lashlines with a pearl highlighting pencil, and follow with black mascara. Brush cheekbones with brick-red blush, and swipe lips with a magenta lip stain.

Patricia Velasquez

My good friend supermodel-actress Patricia was born in a poor region of Venezuela, and has dedicated much of her life to promoting the fair treatment of her country's indigenous peoples. Her activism only makes her more beautiful. Here, with her lush, crimson-red mouth, penetrating dark eyes, and luminous skin, she's the ultimate tropical South Pacific princess. *Mmm . . .* smell the tiare flowers, feel the humid, sensuous air, sense the distinct possibility of getting "lei'ed" (couldn't resist), and try this look on for size.

"My father is a mestizo combination of Spanish and indigenous, and my mom is a Wayuu Indian. My looks made me special because I'm from a group of people that hadn't been represented before in the modeling industry."

Get the Look
Dot and blend a sheer champagne highlighter along forehead, cheekbones, bridge of nose, and chin. Blend an apricot cream shadow from lash to crease, and a pearl cream shadow along browbone. Trace upper lashline with black pencil and bottom lashline with copper pencil. Finish with black mascara, coral cream blush, and raspberry lipgloss.

J a d e J a g g e r

Everything about Jade Jagger screams royalty—and no, this isn't another reference to her "Mick and Bianca" bloodline. She has that *thing* all on her own—a singular, they-threw-away-the-mold beauty (could it be her Nicaraguan and British heritage?), amazing artistic talent (she's the creative director for Garrard jewelry), and a wild, boho-gypsy streak (she lives on Ibiza and houses guests in chic backyard teepees!). Here, she sports an island water-nymph look, with a wash of sea-blue shadow, sun-kissed cheeks, and sea-sprayed hair.

> "I love the way my mother pushed the boundaries with her ever-evolving style. She's my long-standing beauty icon."

Get the Look
With fingers, blend a periwinkle cream shadow from lashes to crease, and along bottom lashline (don't try to be perfect—the messier, the sexier). From crease to browbone, blend on a pale lavender cream shade. Line bottom lashes with midnight-blue eye pencil, and apply two coats of mascara. Brush on bronzy blush, and apply a sheer coral lipgloss.

Kimora Lee Simmons

Model-turned-entrepreneur Kimora Lee Simmons lives a life that would make Ivana Trump turn green, and we love her for it! From designing the clingy-sexy Baby Phat line to owning the largest Louis Vuitton luggage collection in the world (forget decorating the palace she shares with her husband, Russell, and their darling tots) Kimora, who's of Korean, Japanese, and African-American heritage, has earned the right to be flashy. But instead of accentuating her trademark curves or dousing her in diamonds, I wanted to present her differently, as a soft snow queen under the night sky.

"I love Dorothy Dandridge—she was a glamorous, breathtakingly beautiful actress who broke racial barriers and emerged as the first black woman ever nominated for a Best Actress Oscar.

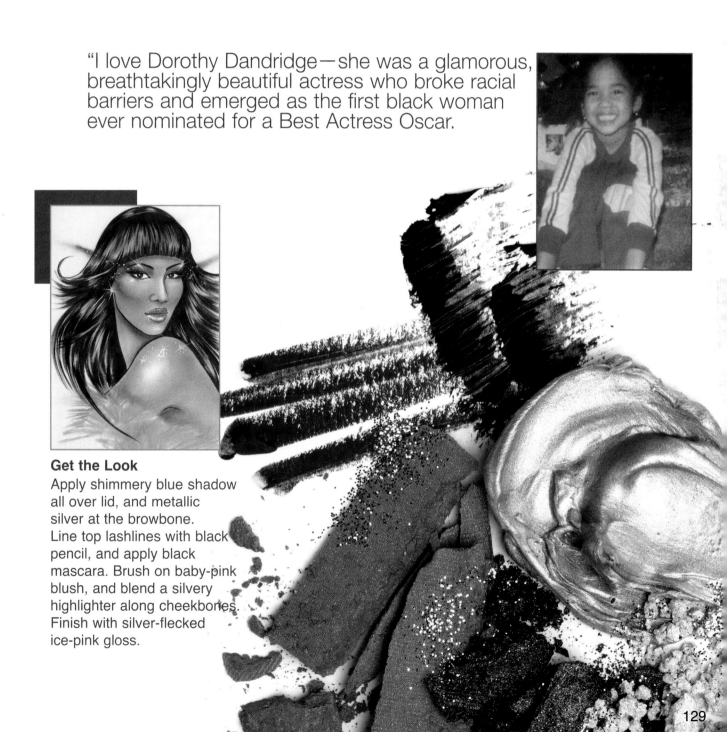

Get the Look
Apply shimmery blue shadow all over lid, and metallic silver at the browbone. Line top lashlines with black pencil, and apply black mascara. Brush on baby-pink blush, and blend a silvery highlighter along cheekbones. Finish with silver-flecked ice-pink gloss.

T y r a B a n k s

When people think of Tyra, they imagine her smoldering eyes, *America's Next Top Model*, her *Sports Illustrated* swimsuit issue cover (the first African-American)—but I always think of her brains. She's a born businesswoman who manages to make multi-tasking look sexy. In ten years, she'll be the next Oprah—but for now, she's an ethereal wood nymph, a gossamer-strewn fairy goddess from the imagination.

"Want to make your eyes look bigger and brighter? Put white eyeliner on the inside rim of your lower lid—always works."

Get the Look
Apply matte mauve shadow from lash to just below browbone, and in a thin line along bottom lashes. Dust an ivory shadow along brow. Line top lashline with a skinny eye pencil, curl lashes, and apply three coats of black mascara. With fingers, blend a sheer rose cream blush onto the apples of the cheeks, and line and fill in lips with a rose lip liner.

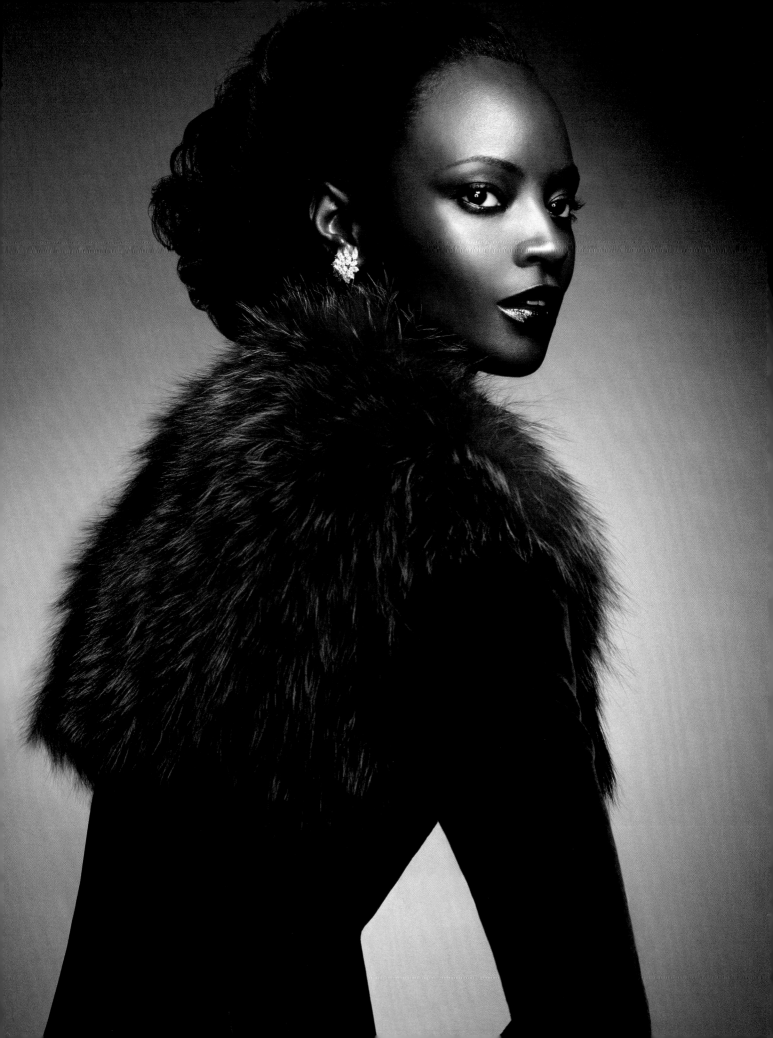

Kiara Kabukuru

Oh, that beautiful dark mahogany skin! I first photographed Ugandan-born Kiara for IMAN Cosmetics back in 1994 with famed lensman Michael Thompson. A decade later, she's one of a handful of black models to have appeared on the cover of American *Vogue* and to have landed a much-coveted Cover Girl contract. The girl is fabulous. Don't mess with her. And with this ultra-chic, extra-pulled-together, modern *Dynasty* look, who would?

"I love using makeup to contour and highlight—with those tricks, you can focus on the features you want, and take away from those you don't."

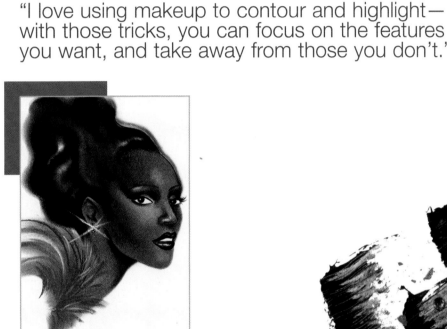

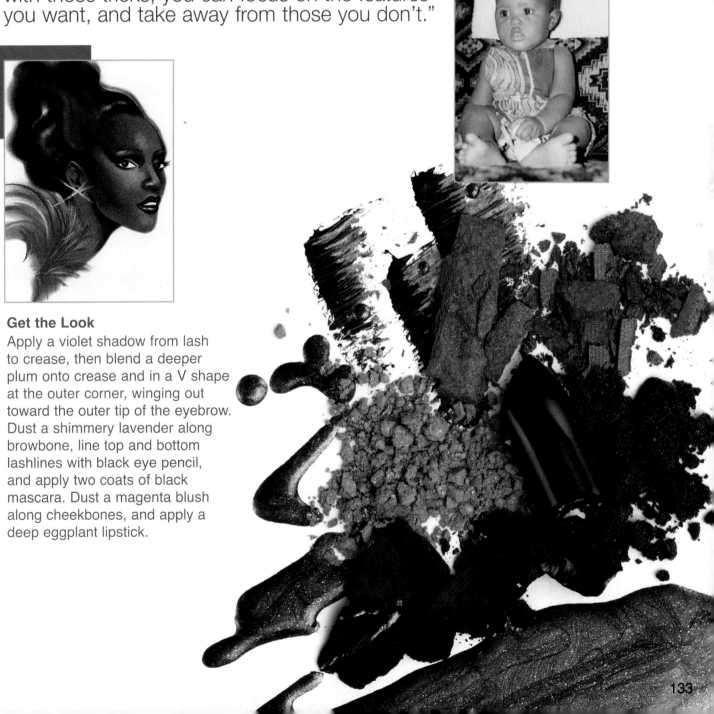

Get the Look

Apply a violet shadow from lash to crease, then blend a deeper plum onto crease and in a V shape at the outer corner, winging out toward the outer tip of the eyebrow. Dust a shimmery lavender along browbone, line top and bottom lashlines with black eye pencil, and apply two coats of black mascara. Dust a magenta blush along cheekbones, and apply a deep eggplant lipstick.

133

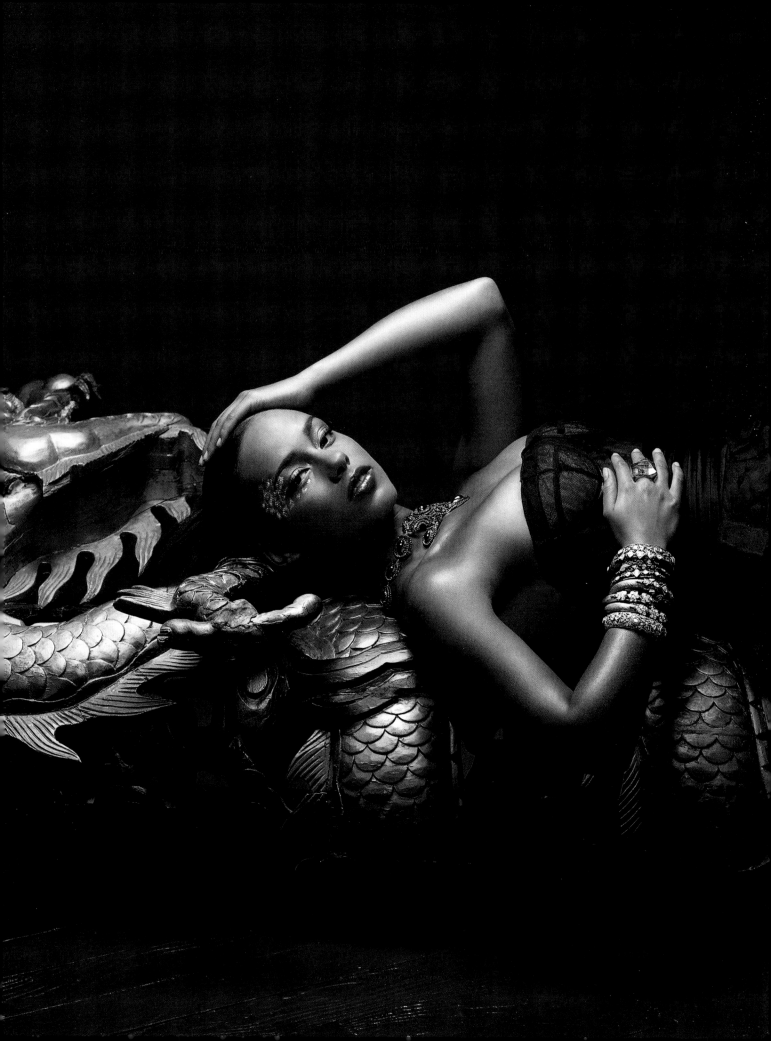

A l i c i a K e y s

Alicia is an old soul. The biracial prodigy from Manhattan's Hell's Kitchen was playing classical piano at seven, songwriting at fourteen, graduating high school at sixteen, and dropping her debut album, the Grammy-winning, multiplatinum, internationally huge *Songs in A Minor* at nineteen. Whose voice is as moodily melodic? Who gives the piano more sex appeal? She's a throwback to the era of smoke-filled jazz clubs, of gin-drinking, bob-haired women and smooth-talking men with slow smiles and fast hands.
But I wanted to see her as a vamp, a Singapore-sexy seductress—and it worked.

"I think eyes are the most beautiful part of a woman. We have so much strength inside of us, and in our eyes you can see it all."

Get the Look
Apply a copper shadow onto lid. Sweep an electric-blue liquid liner along upper lashline, smudge an emerald eye pencil along lower lashline, and apply black mascara. For extra drama, dip a concealer brush into gold cream shadow and create dots around outer corner of eye. Finish with a burnished red-brown lipgloss.

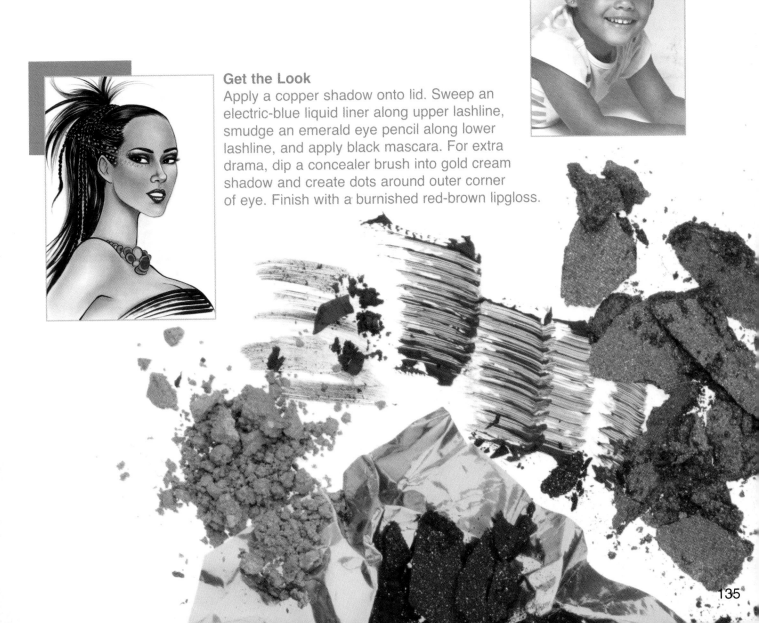

5 MOST WANTED
Makeovers at Every Age

Orchids, sunsets in Seville, virtually any shoe Christian Louboutin makes, Klondike Bars—those things are pretty, but knowing what makeup looks great on you, and working it with confidence, ease, and wit, no matter your age?

Now *that's* beautiful.

"Makeup should be easy to carry, to use, and to wear. And it's not about covering up—it's about enhancing what you've got."
—Christy Turlington, Ecuadoran-American, supermodel and entrepreneur

Teens

Name: Diandra Erica Malahoo
Age: 14
Ethnicity: Caribbean-American
Occupation: student
Usual Makeup Look: lipgloss, mascara, eyeliner

How-to

1. Clean up "virgin" brows by brushing upward and plucking stray hairs underneath. If you're having trouble finding your arch, feel free to cheat by using an eyebrow stencil. Next, prep oily or combination skin with a gentle, non-comedogenic cleanser and follow up with a moisturizing gel.

2. Use an oil-free liquid foundation that gives great, natural-looking coverage without clogging pores (you can even find some containing salicylic acid to fight blemishes). Use a sponge to swipe it over forehead, nose, and cheekbones—and blend.

3. Look-at-me electric makeup hues are hot if you're performing "Lady Marmalade" with Lil' Kim at Madison Square Garden, but for a regular school day, think pretty, fresh, and not-too-done. Simply brush a neutral taupe shade over lids, a rosy hue on apples of cheeks, and dab a sheer ballerina-pink gloss on lips.

Skin Secret for Teens

If you have acne on your back or shoulders (prettily nicknamed "bacne" or "back-ack") *gently* wash with salicylic acid–infused body cleanser every day.

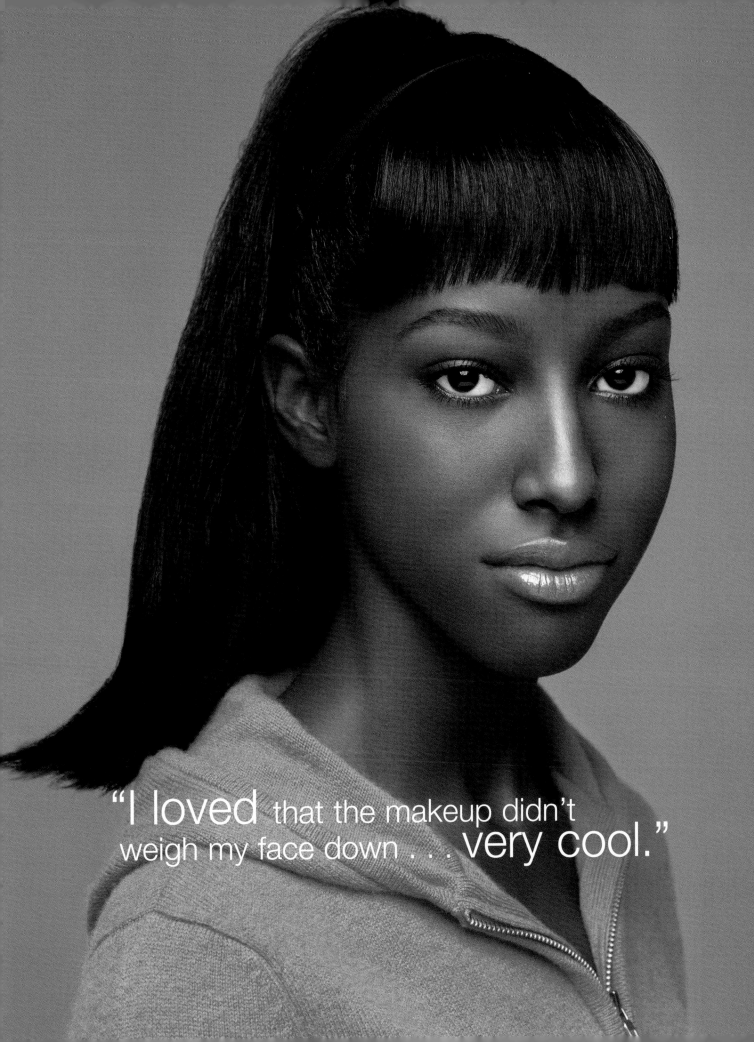

"I loved that the makeup didn't weigh my face down . . . very cool."

Teens

Name: Linda Wong
Age: 19
Ethnicity: Chinese, German, Dutch, Irish
Occupation: teacher's assistant
Usual Makeup Look: black eyeliner and burgundy lipstick

How-to

1. Too-sparse brows call for filling in. With a brunette brow pencil, make short, quick strokes across the brow to create a sexy, fuller appearance. For the most natural look, always blend in with a brow brush, and set.

2. Combat undereye bags by dotting on a yellow-based concealer in a half-moon shape—from tear duct to just above the top of the cheekbone to the outer corner of the eye. Next blend on a sheer liquid foundation, and set with loose powder.

3. Eyes this sexy are perfect for the prom, flirting with your best friend's big brother, or a night out with the girls! First blend a vanilla shimmer shadow all over the lid, and apply a matte yellow shade at the inner corner. Next line top lashline with black pencil.

4. For maximum drama, trace shimmery emerald liquid liner over the black eye pencil on the top lashline, and a green eye pencil along the bottom lashline. Curl lashes and apply three coats of black mascara.

5. Keep the rest of your face low-key. Complete the look with tawny blush and a touch of cotton-candy-pink lipgloss.

Skin Secret for Teens
Change your pillowcase once a week to keep oil, dirt, and dust away from your skin.

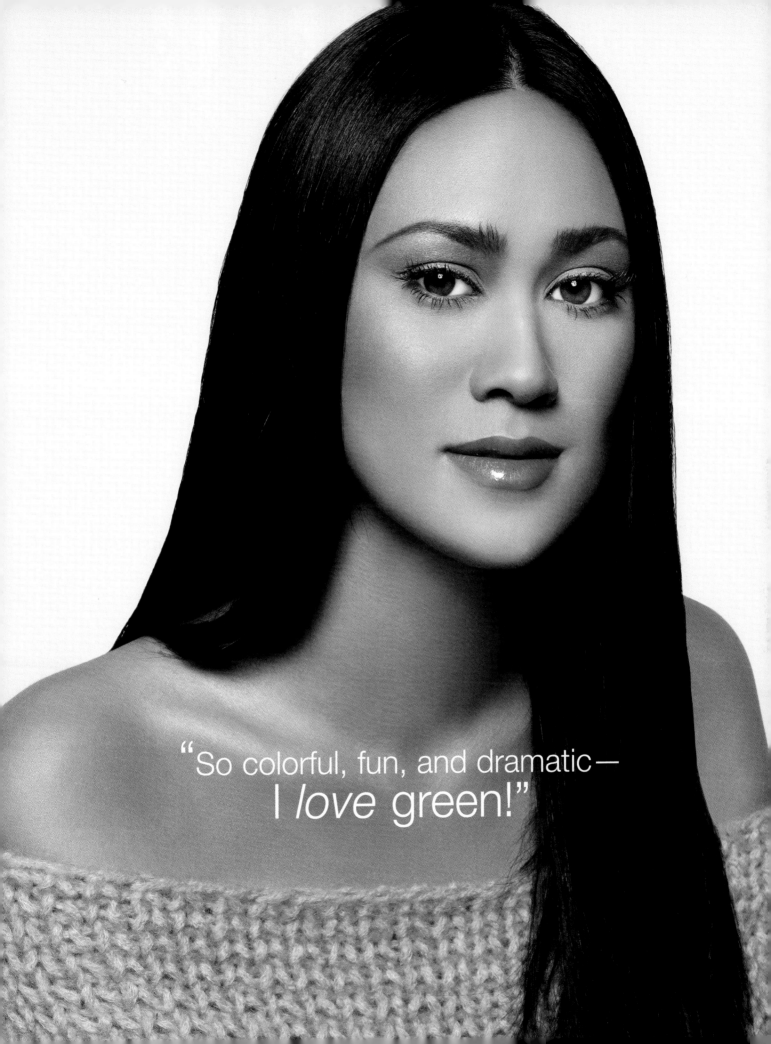

"So colorful, fun, and dramatic—
I *love* green!"

20'S

Name: Amy Lee Hastanan
Age: 24
Ethnicity: Puerto Rican, Thai
Occupation: fashion executive
Usual Makeup Look: black liner and lots of mascara

How-to

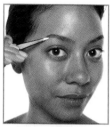

1. Not all brows are created equal. Amy's actually have a distinct natural arch, so we just enhanced the shape by tweezing a few stray hairs underneath.

2. Mixed-race women often have various tones in their skin. Use concealer as a tool to even out your complexion. Here, we applied a honey concealer under the eyes, around the mouth, and at the perimeter of the face before applying foundation.

3. For super-sultry eyes, apply a charcoal shimmer shadow all around the eye and rim in black pencil. More of a colorful girl? There's no rule that smoky eyes have to be charcoal or black—try purple, rust, or bronze.

4. Apply lots of black mascara, and highlight the browbone with a pearl hue. Warm up cheeks with an orangey-gold blush. Don't be scared of orange blush—it immediately warms up your complexion, no matter your skin tone.

5. Now for the mouth. It's a sexy, pouty pucker, and we got it with a gold-flecked coral gloss. Don't even think about liner—it's sexier without. You know, a slightly smudged, sipping-cocktails-and-making-out-all-night finish.

Skin Secret for Twentysomethings

Stop smoking and cut down on all those gin-and-tonics!
Too much partying will eventually make you look like Keith Richards.

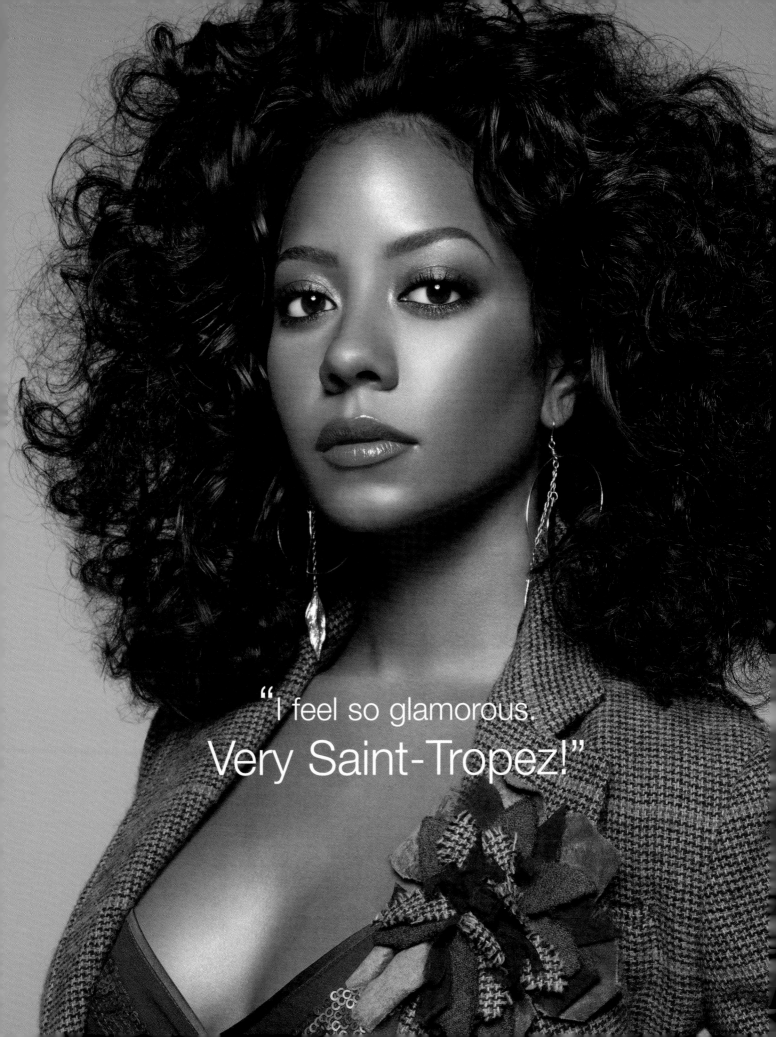

"I feel so glamorous. Very Saint-Tropez!"

Name: Keesha Johnson
Age: 29
Ethnicity: Jamaican
Occupation: publicist
Usual Makeup Look: sheer pink lipgloss and mascara

How-to

1. We're not always born with the hair color we're meant to have—I firmly believe this. Rita Hayworth was the consummate redhead, but in truth, this legendary Latina had coal-black hair. I'm convinced chestnut-haired Keesha is meant to be a tad more golden, and the brows were the first to go blonde.

2. For a twinkly finish, dust on powder foundation containing subtle gold shimmer. To add depth to a round face like Keesha's, swipe a bronzer stick along hairline and under cheekbones, and gently blend with a sponge.

3. For sun-kissed eyes, blend gold shadow all over lid and browbone, and a shimmery bronze-brown shade onto crease and along bottom lashline. Line top lashline with black pencil, and blend.

4. For super-diva lashes, apply a coat of volumizing mascara. Then apply false lashes, curl, and apply two more coats of black mascara. Wake up cheeks by dusting on a matte orange blush.

5. The golden glamour-girl look is topped off with a lush, gilded mouth. Line lips with a coffee pencil, blend inward with a lip brush, and layer on a nude, toffee-hued lipstick. Finish with a sheer gold lipgloss.

Skin Secret for Twentysomethings

In your twenties, adult acne is a possibility. Whatever you do, skip the acne-fighters from your teen years—too harsh for your "grown-up" skin. Instead, see a dermatologist for a topical retinoid or an oral antibiotic.

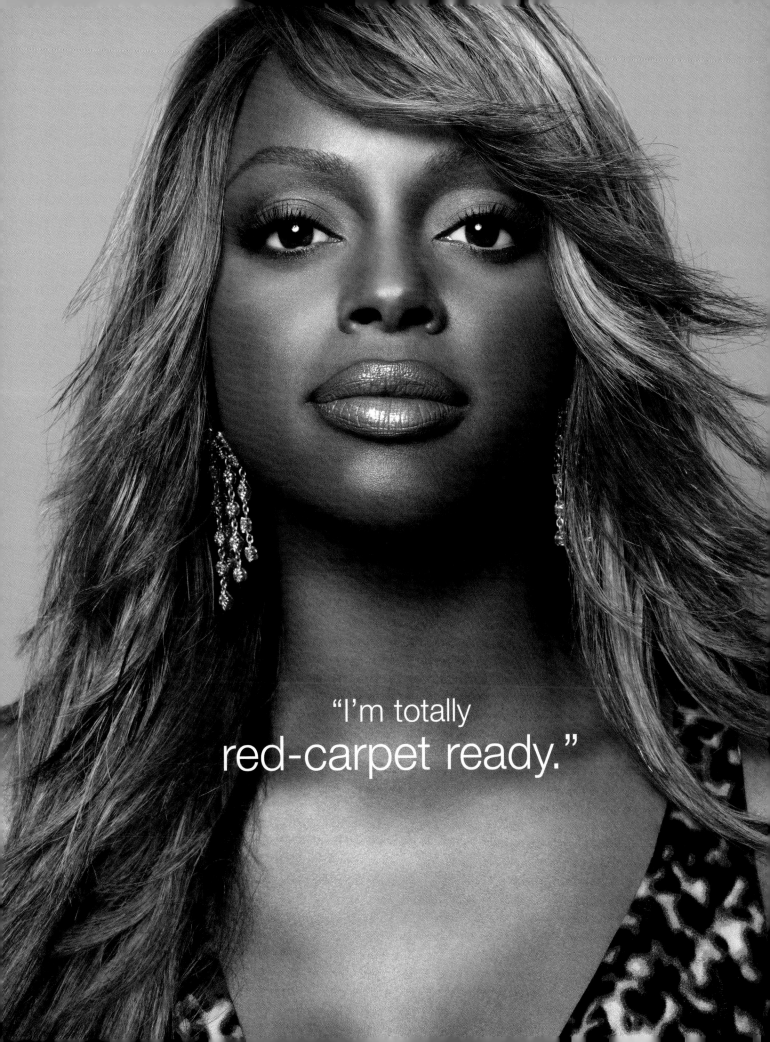

"I'm totally
red-carpet ready."

Name: Marie Cabret
Age: 31
Ethnicity: Puerto Rican
Occupation: homemaker
Usual Makeup Look: sheer pink lipgloss and mascara

How-to

1. If you've got great skin and sexy freckles, don't cover them up with tons of makeup! Skip concealer and use a soft-coverage, sheer liquid foundation. Dot it on forehead, cheeks, and chin, and blend.

2. For a radiant glow, blend a light, sheer luminizing stick where the sun naturally hits your face—bridge of nose, cheekbones, and across the forehead. Or simplify things by adding three drops of liquid illuminator into your bottle of liquid foundation.

3. To add warmth and vibrance, blend a shimmery pink cream blush over apples of cheeks, extending upward. Time-saving tip: If you're ever in a major rush, apply only the luminizer and blush. You'll look awake and "finished."

4. For this look, the focus is on gorgeous, radiant skin. So skip eyeshadow, and instead curl your lashes and apply two coats of mascara to top and bottom lashes.

5. Finish with a slick of neutral pink lipgloss—no liner, no blotting, no fuss.

Skin Secret for Thirtysomethings

Choose products containing antioxidants like vitamin C or green tea extract to protect your skin from harmful environmental elements, such as pollution, secondhand smoke, and free radicals.

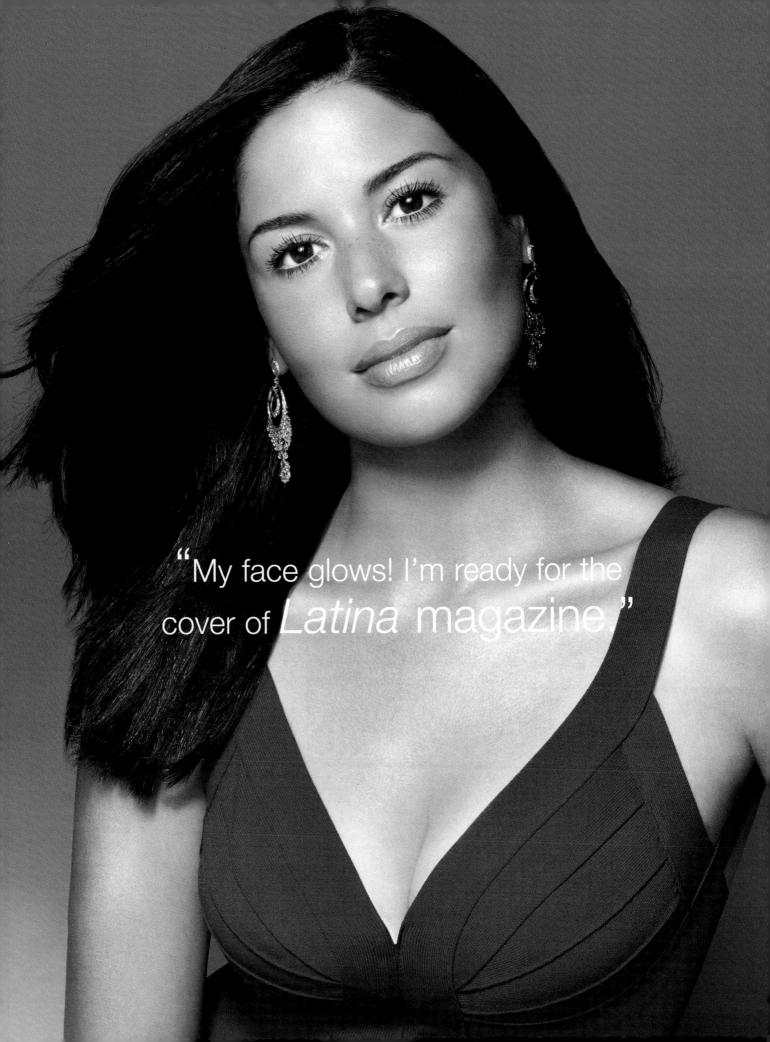

Name: Maddy Madrid
Age: 30
Ethnicity: Filipino
Occupation: public relations
Usual Makeup Look: bronzer and mascara

How-to

1. If you have sparse brows, don't go crazy with the tweezers! Simply clean up stray hairs, then fill in with a brunette brow powder and a tiny, stiff brow brush.

2. Prep skin with an oil-free moisturizer. To manage combination skin like Maddy's, apply a yellow-toned balancing foundation. Apply concealer under eyes and around nose and mouth.

3. For an impeccably shine-free finish, use a large, fluffy puff to press loose translucent powder into skin, setting foundation and concealer. Next give cheekbones sexy dimension with a sheer coppery blush.

4. Who said businesslike had to be boring? For an eye that's equal parts boardroom and bedroom, blend a coffee shimmer powder all over lid and along bottom lashline, and apply a pearl highlighter along browbone. Rim eyes with black pencil, curl lashes, and apply mascara. Finish with a rust lipstick.

Skin Secret for Thirtysomethings

Resist yo-yo dieting—it just causes your skin to lose its elasticity and start to sag prematurely.

"At work people mistake me for 21—now I look **more polished and professional.**"

40'S

Name: Gena Avery
Age: 40
Ethnicity: African-American
Occupation: executive assistant
Usual Makeup Look: natural

How-to

1. Many brown-skinned women have hyperpigmented areas on their skin. To create an even tone, start by applying a creamy yellow-hued concealer under the eyes, and over any blemishes or dark areas.

2. Next swipe a cream stick foundation all over, and carefully blend with a sponge. Make sure you blend into your neck and jawline, for the most natural look. Remember, the best way to avoid "mask face" is to find a foundation that flawlessly matches your skin tone.

3. Set concealer and foundation with a matching pressed powder. Give your skin a shot of warm, sun-kissed sparkle by dusting a powder bronzer onto cheekbones. Fill in brows with brown powder.

4. Blend a brown shimmer shadow all around the lid, winging upward at outer corner. Rim eyes with black pencil, and apply two coats of black lengthening mascara. Apply a cinnamon-hued blush.

5. Forget all those ridiculous rules about how to make full lips look smaller— you know, lining just inside your natural lip line, avoiding gloss, and so on. People pay thousands for full lips, so flaunt them! Line with a mahogany pencil, brush on coffee lipstick, and top off with a sheer golden gloss.

Skin Secret for Fortysomethings
No matter your skin type, every product in your skin-care regimen should be moisturizing—not drying.

"This look really brought out the glamorous side of me."

40'S

Name: Michele Ramos Johnson
Age: 41
Ethnicity: Puerto Rican
Occupation: homemaker
Usual Makeup Look: moisturizer

How-to

1. To give a golden glow to olive skin tones, bleach dark brows a warmer, more honey-toned, caramel shade. After bleaching, pluck stray hairs and fill in with golden-brown pencil. If you have dry skin, first apply a hydrating moisturizer; this also gives skin an even surface, so makeup doesn't settle in fine lines.

2. To cover up redness and any dark areas, apply a creamy golden-beige concealer under the eyes and around the nose and mouth, and blend into the skin with a sponge. To set without hiding those sexy freckles, dust on sheer loose powder.

3. Apply a plum shadow from lashline to crease, and along bottom lashline. With a thin black pencil, trace a thin line at top lashline.
Reminder: Don't tug on skin around the delicate eye area while applying liner—this creates major wrinkles.

4. Curl lashes and apply two coats of volumizing mascara to top and bottom lashes. To add a burst of color to your complexion, blend a rosy blush onto cheekbones, and slick a strawberry-pink gloss onto an unlined mouth.

Skin Secret for Fortysomethings

Once a month, book yourself a microdermabrasion treatment, or use an at-home kit (top beauty brands are selling them at drugstores now) This will help smooth out fine lines and maintain a youthful glow.

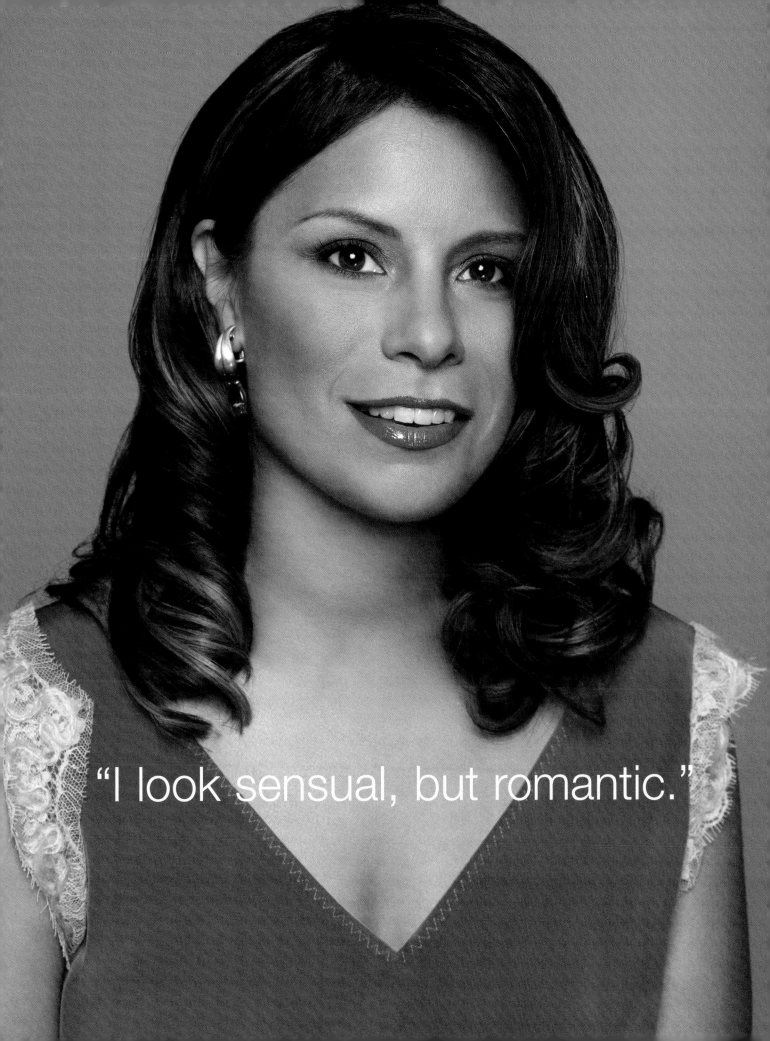

"I look sensual, but romantic."

50'S

Name: Carol Ingram
Age: 55
Ethnicity: African-American
Occupation: executive assistant
Usual Makeup Look: powder and lipstick

How-to

1. The easiest way to groom sparse, overplucked brows is by using stencils. Lay an open stencil over your brow area, and fill in with a brunette brow pencil with short, precise strokes. If, when you remove the stencil, the brow is artificial-looking, blend a bit with a tiny, firm brush.

2. Conceal discoloration along browbone, cheeks, and undereye area and around mouth with a caramel-hued foundation. If your skin is oily, but you need more coverage than a liquid formula, go for an oil-free foundation stick. You'll have a full, matte finish without that heavy, greasy, clogged-pore feeling.

3. Set foundation by applying pressed mahogany powder all over (loose powder settles in fine lines and wrinkles). A great tip: Always keep a pressed powder compact in your purse for shine attacks during the day.

4. Apply a matte purple shadow from lashes to crease, a lighter matte violet shadow from crease to just under browbone, and a pearl shadow along browbone. Rim eyes with black eye pencil. Avoid shimmer shadows—these settle into fine lines, highlighting crepey skin.

5. Curl lashes and apply black mascara. Brush on sheer russet blush, line lips with a wine-colored pencil, and fill in with a berry lipstick. To make ultra-sexy cheekbones even hotter, blend a sheer gold shimmer powder along top of cheekbones, up to temples.

Skin Secret for Fiftysomethings

If you spent the last thirty years stressing out over career, kids, and relationships, then stop, woman, because it's showing on your hard, tense, lined face! Relax your facial muscles, unclench your jaw, get a pedicure. Chill out—your skin will reward you.

"I feel so sexy with the red lipstick!"

50'S

Name: Leslyn Gittens
Age: 56
Ethnicity: Guyanese, South American, African, East Indian, Irish
Occupation: UN programmer
Usual Makeup Look: eyeshadow, mascara, and lipgloss

How-to

1. To prevent concealer from caking, first apply eye cream. Then, with a sharp brunette brow pencil, fill in sparse brows with short, fine strokes.

2. For oily-to-normal skin like Leslyn's, apply liquid foundation with a sponge all over. To create the illusion of contour on a round face, apply pressed powder bronzer along the hairline, bridge of nose, and just under the cheekbones.

3. Blend a deep coppery-brown shadow on eyelid, and a golden-apricot shadow at the crease. Apply an ivory hue along the browbone, and with a chestnut eye pencil, rim top and bottom lashlines. Apply false lashes to top lid, curl, and apply mascara.

4. To top off the bronze goddess look, brush a toasty blush onto the apples of the cheeks, and line lips with a cinnamon-hued lip pencil. Use a lip brush to blend the pencil inward; then apply a bronze lipstick.

Skin Secret for Fiftysomethings

You might be experiencing postmenopausal skin-care issues, such as red veins and age spots (especially if you have fairer skin). Combat this by using a vitamin C serum before your daily moisturizer.

"I just love this makeup....I feel very flirty!"

6 RED-CARPET READY
My Secret Tips for Ruling the Red Carpet

People are always asking me to divulge my red-carpet secrets—my favorite out-all-night lipgloss, my tips for posing for paparazzi. And I've always answered coyly, "Oh, it's all about a wink and a smile." Yeah, right. Well, girls, for the first time ever, here's the truth!

"Honey, you're born naked. Everything else is drag."
—RuPaul, African-American, entertainer

On a night of cocktails and air-kissing, you can be sure I'm armed with these get-hot-in-seconds staples:

1. Blotting Papers: Whether it's the paparazzi or your uncle Harry snapping the shot, grease is never the word when it comes to photo ops. I stop mid-soiree shine with portable oil-absorbing tissues.

2. Opaque Bronze Lipgloss: Sheer gloss at night? Kids' stuff! High-wattage gloss in a neutral metallic is so sexy—the shade's subtle, but the luscious, vinyl-like finish is very grown-up.

3. Travel-Size Fragrance: No matter what your perfume promises, if you're partying hard enough, it will fade. I always carry a travel-size version of my signature scent for emergency fragrance-reviving.

4. Mirrored Compact: Because nothing's tackier than checking your teeth for poppy seeds in the butter knife.

5. Blush Stick: If hours of dancing render your makeup a shadow of its former self, this lifesaving, multitasking stick will not only brighten up your cheeks, it will also work as eyeshadow and lipstick!

credits

I would like to thank my executive assistant, Lorraine Krich, for micromanaging this project, and Oscar Reyes for his invaluable help. Thanks also to all the models, celebrities, and "real" women for giving their time and spirit to make this book possible. I am forever grateful to the makeup artists and hair stylists who tirelessly and effortlessly brought my vision to reality, and my sincerest gratitude to all the photographers for believing in my vision.

My sincerest thanks to the modeling agencies that accommodated my requests at a moment's notice: NEXT Model Management, NY Models, Elite Models, Wilhelmina Models, Women, IMG Models, Trump Model Management, Ford Models, Karin, Major Model Management, 1 Model Management, Q Models, and Request Models.

Mostly, I would like to thank my collaborator and friend Tia Williams for her expertise, girlishness, and sense of humor; and my deepest appreciation to Vincent Nigro, for his good taste, gentlemanly manners, and extreme patience. Finally, I am deeply grateful to everyone at Putnam for their guidance and belief in this project.

Art direction and design: Vincent Nigro
All still life: Roberto Bosnan
Digital capture equipment: Phase One
Digital support: Digital Transitions (NYC)
Retouching: Wrench Ltd.
Additional retouching: Cecil Appleton
Illustrations: Alvaro
Stylist: Iman

Cover photo © Alex Beauchesne
Iman's cover makeup: Sam Fine; hair: Chuck Amos
Theresa and Song cover makeup: Stephen Demmick; hair: Kheli French
Back cover photos by Troy Word, Michael Ruiz, Carlo Dalla Chiesa, and Herb Ritts

Photography: Alex Beauchesne: pp. 15, 27, 32, 42, 45, 49, 72, 140, 141, 142, 143, 144, 145, 152, 153, 154, 155, 156, 157. Daniel Carriga: pp. iv, vi, 51, 88, 163. Jemal Countess, Kevin Mazur, Amy Graves, Alan Davidson, Tony Barson (all Wireimage.com): p. 161. Carlo Dalla Chiesa: pp. 104, 120. Alan Davidson, Jemal Countess, Jeff Vespa, RJ Capak, Theo Wargo (all Wireimage.com): p. 160. Arthur Elgort, Peter Beard, Majid, Inc., Antonio Lopez, IMAN Cosmetics: p. 4. Markus Klinko and Indriani: pp. 69, 128, 166. Roxanne Lowitt: p. 158. Majid, Inc.: pp. 164, 165. Patrick McMullan: p. 161. André Rau for IMAN Cosmetics: p. 55. Herb Ritts: p. 102. Mike Ruiz: p. 130. Hyungwon Ryoo: p. 2. Warwick Saint: p. 112. Stephane Sednaoui: p. x. Stewart Shining: p. 134. Spicer: pp. 31, 41, 57, 62, 70, 80, 82, 94, 100, 110, 122, 126, 132. Ellen von Unwerth: pp. 108, 114, 118, 124. Wireimage.com: p. 90. Troy Word: pp. 9, 25, 27, 29, 35, 39, 49, 59, 67, 72, 74, 75, 78, 84, 86, 90, 92, 96, 106, 116, 138, 139, 146, 147, 148, 149, 150, 151, 163. Backstage Pass (All Majid, Inc.): pp. 164, 165.

Makeup: Byron Barnes: pp. 154, 155, 156, 157. Fran Cooper: p. 55. Stephen Demmick: pp. 15, 27, 32, 42, 45, 49. Sam Fine: pp. 67, 74, 75, 92, 104, 142, 143, 144, 145, 146, 147, 150, 151. Fiona: p. 120. Charlie Green: pp. 62, 70, 110, 116, 126. Frances Hathaway: p. 128. Lazarus Jean Baptiste: pp. 152, 153. JJ: p. 112. Jay Manuel: pp. 3, 9, 27, 29, 31, 35, 39, 41, 49, 51, 57, 59, 69, 78, 80, 84, 86, 88, 90, 94, 100, 106, 108, 114, 118, 124, 130, 138, 139, 148, 149. Paul Starr: pp. x, 102. Ashunta Sheriff: p. 134. Romy Soleiman: pp. 82, 122, 132. Rudy Sotamayer: pp. 10, 141. Eyebrow grooming by Vashaya: pp. 153, 155, 157.

Hair: Chuck Amos: pp. 100, 104, 128. Luke Baker: p. 130. Suzette Boozer: p. 112. Kheli French: pp. 15, 27, 32, 42. Johnny Gentry: pp. 152, 153, 154, 155, 156, 157. Quentin "Q" Hardy: pp. 146, 147, 150, 151. Oscar James: pp. 3, 9, 27, 31, 39, 41, 57, 59, 69, 78, 80, 84, 86, 88, 90, 92, 94, 96, 106, 114, 116, 118, 124, 138, 139, 140, 141, 142, 143, 144, 145, 148, 149. Ellin Lavar Extensions: p. 155. Chris McMillan: p. 102. Miki: pp. 82, 122, 132. Oribe: p. 108. Rod Ortega: p. 120. Satoru: pp. 62, 110, 126. Peter Savic: p. x. Nicole Tucker: p. 134.

Manicures: Deborah Lippmann: p. 112. Myrdith McCormack: p. 120. All additional manicures: Nails by Decca.

Designers: Roberto Cavalli: p. 145. Dior: p. 110. DKNY: pp. 59, 141, 143. Dolce and Gabbana: pp. 94, 114. Norma Kamali: pp. 112, 120. Donna Karan: pp. 78, 104, 122. Hedi Slimane for Dior Homme: p. 110. Anna Sui: p. 132. Adrienne Landau: p. 120. Herve Leger: p. 147. Monique Lhuillier: p. 134. Luca Luca: p. 151. Missoni: p. 96. Emanuel Ungaro: p. 155. Plein Sud: p. 157. YSL: p. 82.

Jewelry: DVF for H. Stern: p. 134. Fred Leighton: p. 134. Robert Lee Morris: pp. 104, 157. Sol Rafael: p. 145. Lorraine Schwartz: pp. 114, 147, 151. Tiffany: p. 153.

Salma Hayek appears courtesy of Avon. Liya Kebede appears courtesy of Estée Lauder. Kiara Kabukuru appears courtesy of Cover Girl. Eva Mendes appears courtesy of Revlon. Location: Industria Superstudio, New York City. Transportation: Bermuda Car Services.

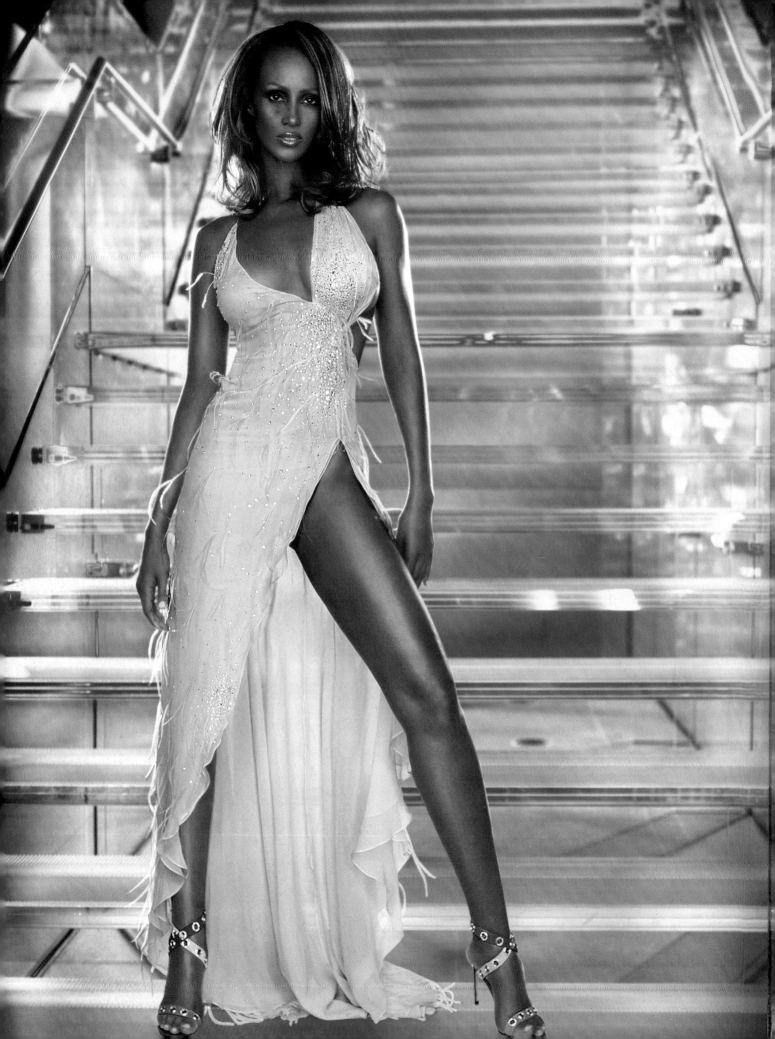